FORTUNE

THE ART OF COVERING BUSINESS

FORTUNE

THE ART OF COVERING BUSINESS

Foreword by John Huey

Historical Essay by Daniel Okrent

GIBBS·SMITH
P
PUBLISHER

SALT LAKE CITY

First Edition

99 00 01 3 2 1

Published by
Gibbs Smith, Publisher
P.O. Box 667
Layton, Utah 84041
Orders: (800) 748-5439
www.gibbs-smith.com

Design by
Michael D Meyers
Axiom Design, Salt Lake City

Printed and bound in Japan

Many of the excerpts in this book have been condensed.

Thanks to the staff of Weber County Library,
Ogden, Utah, for their generous research cooperation.

Thanks to Edith Firoozi Fried, Patty Hodgins, Michele McNally,
William Nabers, Margery Peters and Deirdre Verne.
Special thanks to Bill Hooper of Time Inc. Archives.

LIBRARY OF CONGRESS CATALOGING-IN-PUBLICATION DATA

Fortune: the art of covering business.
p. cm.
Cover art and selected excerpts from
Fortune magazine, 1930–1950.

ISBN 0-87905-932-X

1. Fortune. 2. Magazine covers—United States.
3. Journalism, Commercial—United States—History.
I. Gibbs Smith, Publisher. II. Fortune.

HF5001.F767 1999

051—dc21 99-16720

CIP

To order FORTUNE magazine, please call (800) 621-8000.

For lithograph reproductions of vintage FORTUNE covers,
contact Front Line Art Publishing at (800) 321-2053.

Contents

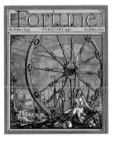

FOREWORD

PROBABLY THE MOST DAUNTING ASPECT of editing FORTUNE is the august legacy of the magazine as it approaches its seventieth year. Few magazines that are vital today go back nearly that far, and those that do make for some fairly auspicious company: our cousin *Time, The New Yorker,* a handful of others.

Daunting though it may be, it's probably for the best. My colleagues and I are each day aware of the tradition we are charged to uphold, while at the same time we know that part of that tradition—something that's always been part of this magazine—is constant reexamination of what we're here for, and what we're meant to be doing.

In most ways, business in America is radically different from what it was when FORTUNE was founded. That was before Social Security, before the sitdown strikes of the thirties, before the creation of the SEC. This last fact alone makes the accomplishments of our predecessors all the more remarkable: the disclosure requirements for public companies were virtually nonexistent. Annual reports were devoid of meaningful numbers, proxy statements were opaque at best, 10-Ks hadn't been invented. The business journalist of 1930 had to either work awfully hard to get the facts, or write with such felicity that no one knew the facts were missing.

Today we strive to do both, even though—maybe because—the business landscape has undergone a series of shifts that have been volcanic in their power and their impact. As a result, we feel the obligation—which is really a pleasure, when you stop to think about it—to build our journalism on strong, aggressive, but always fair reporting, and to convey it to our readers with smart, colorful prose. And while the glory days of gravure printing on 11- by 14-inch sheets of heavy, antiqued paper will never come again, we think today as Henry Luce did seven decades ago that what our magazine looks like matters too. Luce wrote that FORTUNE's purpose is to reflect Industrial Life in ink and paper and word and picture as the finest skyscraper reflects it in stone and steel and architecture.

The best skyscrapers from that period are still standing—and so are the best magazines.

JOHN HUEY
MANAGING EDITOR

"Every Page Will Be a Work of Art"
A Historical Essay

By Daniel Okrent

Luce: "The magazine will look and feel important—even majestic."

There had never been a magazine like it.

From the very first issue—actually, from the moment the notion popped into the head of Henry Luce—FORTUNE was going to be different. Luce and his partner, Briton Hadden, had had just one idea when they founded *Time* in 1923: a weekly magazine that would summarize the news for the busy businessman. But success doesn't merely breed success; it can also spawn a grandness of vision that may not have been there before. And in February of 1929, when Luce first submitted the idea for his new magazine to the Time Inc. board of directors, he cited this in his memo: "The eye," he wrote, quoting Leonardo da Vinci, "giveth to man a more perfect knowledge than doth the ear. That which is seen is more authentic than that which is heard."

"Consequently," he added, "the new magazine will be as beautiful a magazine as exists in the United States. If possible, the undisputed most beautiful."

And so it would.

Lloyd-Smith: At 29, Luce's choice for "the greatest journalistic assignment in history."

Looking through the covers reproduced in this book, it's hard to believe that a magazine that employed such wonderful artists to such thrilling effect was devoted to the subject of business. But given *Time*'s astonishing early success, and given the economic climate of the late twenties, and given the inclinations of the man who had brought the word *tycoon* into popular American usage, it was inevitable that Luce would turn to business as his subject. In fact, he initially intended to call the magazine *Tycoon* (which, until the advent of the Luceian language that came to be known to its critics as *Time*-ese, was strictly the term used to describe the Shogun of Japan to foreigners).

To Luce, business was the great American story, the lives of the men who conducted it the untold saga of America's success. In the magazine's original prospectus, he used the peculiar backward syntax he favored to make this modest claim: "Accurately, vividly and concretely to describe Modern Business," he wrote, "is the greatest journalistic assignment in history."

But from the very moment that what would become FORTUNE took shape in his mind, the magazine was not merely to be journalism. In Luce's earliest memo on the subject, under the heading "Expansion: Business Mag," he elaborated with the assertion that "American business has importance—even majesty—so the magazine in which we are able to interpret it will look and feel important—even majestic." FORTUNE's pre-publication Preface, which outlined the new magazine for potential advertisers, boasted that "every page will be a work of art."

To execute his big idea, Luce plucked Parker Lloyd-Smith from *Time*'s business section to be FORTUNE's managing editor. Lloyd-Smith, who was all of twenty-nine, had studied classics at Princeton but, like so many of the amateurs Luce and Hadden recruited to Time Inc., he had

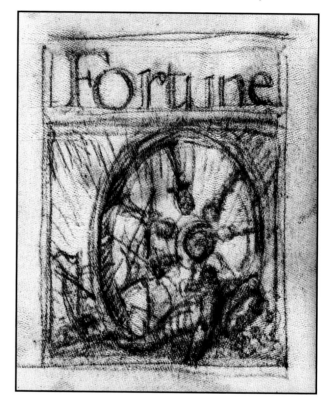

The Cleland sketch: A feat that could make editors pale.

remade himself into a capable and well-liked editorial executive. Blessed with immense charm and a warm, engaging manner, he stepped easily into collaboration both with Luce—who was himself only thirty-one—and, somewhat more surprisingly, with the designer recruited for the project, Thomas Maitland Cleland.

Cleland was described in an internal memo as

"almost the unanimous choice" of printers and publishers as America's foremost authority on both type and design. Although his reputation in the business world was largely predicated on his promotional pieces for luxury products, including a particularly celebrated Cadillac catalogue in 1927, among designers he was honored for the exquisite, classic detailing of his work in several arenas. On the publication of his elaborately printed book *The Decorative Work of T. M. Cleland* (1929), one commentator said, "Printer, fidgeter of type ornaments, painter, theatrical designer, mural decorator—in all these things Cleland's work is illustrious."

And not, in the way he liked to present it, without a certain dramatic flair. Drinking with Lloyd-Smith one night at Bruno's, a speakeasy on East 12th Street, Cleland dazzled his young companion with a feat of the sort of artsmanship that makes editors pale. Drawing freehand on the tablecloth, Cleland sketched out his vision of the first cover, right down to the handsome serifs on the logotype. The tablecloth illustration, framed and still hanging on a wall in the Time & Life Building in New York, was remarkably close to the cover that would appear on the inaugural issue in February of 1930. But what the framed fragment of linen doesn't show is that Cleland drew it upside down—so that Lloyd-Smith, sitting across the table, wouldn't have to turn his head or rise from his chair to appreciate it.

As much as Time Inc.'s directors liked the idea of FORTUNE—they approved it by a vote of 8–2—their timing was slightly unfortunate: as Lloyd-Smith was assembling his staff and other executives were arranging plans for printing, distribution, promotion and all the other tasks that go into publishing a magazine, disaster struck. In the words of Eric Hodgins, later to become both the managing editor and the publisher, "Almost on the eve of FORTUNE's publication, the whole economy of the United States slapped a hand over its heart, uttered a piercing scream, and slipped on the largest banana peel since Adam Smith wrote *The Wealth of Nations.*"

But there's no hubris like the hubris of those who are very successful when very young, and Luce and his editors would not be stopped by a mere stock market crash. Their argument for proceeding, as presented to the board, was a dazzling combination of fingers-crossed self-justification ("Maybe the very fact that business is in for a tough time will make business even more interesting to write about") and cocky economic prognostication that revealed a certain naiveté about the subject they intended to cover: "But we will not be over-optimistic," the memorandum read. "We will recognize that this business slump may last as long as an entire year."

On such intelligence was the magazine launched just a few months into what would be the longest-lived and most severe economic catastrophe in modern history. But what a magazine it was: a mammoth 11 by 14 inches, cover stock stout enough to stand up on its own, gravure printing of the sort you would expect from a museum catalogue (and which for several issues required two separate plants, one for the pictures and one for the text), an interior paper stock so rich, thick and buttery it could nearly cause spontaneous salivation. The admission fee for this two-pound extravaganza was suitably grand too: today it would take $9.77 to buy what a buck (FORTUNE's cover price, when *Time* was selling for 15 cents) could get you in 1930. A subscription was ten dollars; in today's terms, nearly a hundred.

Reaction to the inaugural issue, which featured the industrial photography of the twenty-four-year-old Margaret Bourke-White, was nearly as lavish as the magazine itself. The *New York World* called it "certainly one of the greatest achievements in periodical printing that has ever been recorded." The *Daily Princetonian* burbled "Like Pallas Athene, FORTUNE sprang fully from

MacLeish: The writer "despised" business and industry.

the brain of its creator *Time*," while the *Brooklyn Times* had it "[s]pringing, like Minerva, full-panoplied from the brain of Jove." Greek myth, Roman myth, take your choice. It was pretty special.

And, despite its price and the year of its birth, instantly successful. In its first five years circulation more than tripled, and orders for advertising pages came tumbling into the offices of F. Du Sossoit Duke, the ad director. (Duke, whose name had been Florimond J. Dusossoit until his wife made him change it, hired only ex-college football players more than six feet tall, for reasons about as clear as his name change.)

In a happy confluence of cause and effect, the commercial success was a direct product of the magazine's editorial triumph. Luce's first promotion piece had said, "If Babbitt doesn't like literature, he doesn't have to read it." Fair enough: with Lloyd-Smith, Luce would assemble a staff Hodgins later called "the most brilliant magazine staff ever to exist in America."

He was unquestionably right: Archibald MacLeish, eventually winner of two Pulitzer Prizes (for poetry and for drama), whom Luce allowed to labor each year until he'd made enough money to cover his expenses, then to leave to work on his poems and plays; Dwight Macdonald, fresh from Yale, writing about business at the start of one of the most distinguished careers in American literary criticism; James Agee, certified genius, also a published poet, whose epic chronicle of Depression sharecroppers, *Let Us Now Praise Famous Men*, began as a FORTUNE piece that just wouldn't fit into the magazine.

Said Luce: "Of necessity, we made the discovery that it is easier to turn poets into business journalists than to turn bookkeepers into writers." One doubts it was truly easy—as Hodgins said in his memoirs, this "most brilliant" staff was also "insane, unreliable and alcoholic." Eleanor Hard Lake, one of the famous "girl researchers" (as they were invariably called), said the magazine was "started by a group of emotional amateurs." Agee had to listen to music while writing, she said, preferably Bach. MacLeish could only write on a particular deep-orange paper,

Treacy: She got fine work from the famous and discovered the unknown.

with a special soft pencil. None of them cared much about business. Macdonald was an avowed Trotskyite. Agee told Macdonald that he joined the staff "with eyes rolling upwards." According to Hodgins, MacLeish condescended toward journalism and "despised" business and industry.

But, Hodgins added, MacLeish "dearly loved" FORTUNE. And it's in such professed love, I believe, that one finds the connection between the brilliant writing in the magazine and the epoch-making illustration that graced its pages, and most particularly its cover. For everyone on the staff and everyone who contributed to the magazine knew that it was their goal—their *duty*—to put out the greatest magazine the world had ever seen. This was, of course, precisely the sort of ambition that inspires love in people of talent. To the writers and editors and designers and artists and photographers, the subject didn't matter at all. They just had to be great.

Enter Eleanor Treacy. If Luce was Zeus, then Treacy was definitely Athena—Eleanor Treacy, of fairly limited training, an extremely young woman who managed to hide her age when she joined the prenatal FORTUNE in November of 1929, the woman who comprised the magazine's entire art staff for much of the first two years. And, as it turned out, an art director of true genius.

It was Treacy's good fortune that she was T. M. Cleland's protégé, and it was Luce's good fortune that Cleland had absolutely no interest in staying on to art direct the magazine once he had completed the design template for the first issue. Ralph Ingersoll, who shared the managing editor's spot with Lloyd-Smith and then succeeded him upon the latter's suicide in 1931, insisted that Cleland had only taken the job in the first place because he wanted to find a spot for Treacy; once done, Ingersoll remembered, Cleland "disappeared into Connecticut," from where he would illustrate two more covers (January 1932 and January 1933, both variants of his first cover) and then disappear from

the FORTUNE family. By the fourth issue, Treacy was art director.

It was she who executed Cleland's formal page designs—but in the art she commissioned to appear on those pages, she soared beyond him. As successful as she was at bringing in superb interior illustration (from Reginald Marsh, John Steuart Curry and Ludwig Bemelmans, among others), it was on FORTUNE's broad, handsome face that she concentrated her attention. Reasoning that the gap between commercial art and pure art was not nearly as wide as most considered it to be, she quickly turned her attention to the people she called "easel artists" to make the magazine's covers.

Steven Heller and Louise Fili in their fine book *Cover Story* provide a simple definition of the difference between fine art and commercial art: "the latter is commissioned by a client." The best of those who dominated American magazine illustration—J. C. Leyendecker, Howard Chandler Christy, soon Norman Rockwell—would eventually find their way into museum collections, but back then they were, by and large, contracted to execute a specific task: paint me an airplane, or a portrait of Hoover, or two boys at a fishing hole.

At FORTUNE, it was a somewhat simpler process. The cover subjects, within certain boundaries prescribed by Treacy, were for the first several years nearly irrelevant save for the inevitability of something either festive or pious at Christmastime, and for the occasional single-topic issue. The "cover story," as such, only rarely appeared in FORTUNE. What ran on the cover was instead several galleries' worth of terrific representational art, as often as not unrelated to the issue's contents. But right from the start Treacy and her artists knew not to stray too far, too often;

the editors who approved the commissions were, after all, publishing a business magazine. As a result there is hidden in the wide range of Treacy-era covers nearly a catalogue of rising American industries: shipping in April 1930, air travel in August 1931, radio in October 1931, even accounting in February 1933. Yet for every rail-yard there was a fox hunt, for every chemists' laboratory a scuba diver. Nothing, it appeared, was beyond trying for a FORTUNE artist.*

Treacy's dogged faith in talent was catholic: she could get fine work from the famous (Diego Rivera, Constantin Alajálov, A. M. Cassandre), or she could discover and nurture the unknown. The twenty-six-year-old Antonio Petruccelli had spent the previous two years designing striped patterns for pajamas when "I merely walked in one day, uninvited, with a small portfolio and left it for consideration," he told the English design historian Chris Mullen in 1984. This was summer of 1933. "To my surprise, two were approved for the September and December issues." FORTUNE would publish twenty more Petruccellis before the thirties were over, making him the magazine's most prolific cover contributor in the first decade (and, along with the airbrush master Paolo Garretto, the finest).

Whether in behalf of an unknown like Petruccelli or a titan like Alajálov, Treacy was ferocious in her devotion to the artists. She fought Luce and Ingersoll for faster payment; for better payment (after Lloyd-Smith's death,

Ingersoll sought to cut the fee paid for a cover illustration from $250 to a range of $100–$200); for, as she said in a memo to Ingersoll, paying artists not just for their labor, but "for their knowledge and skills."

Which is not to say that she inevitably sided with the artists when there was conflict. Once she had a sense that the editors

Ingersoll: Treacy considered him "a son of a bitch."

were going in a particular direction, Treacy knew better than to engage in outright resistance. When Petruccelli's cover for an issue devoted entirely to Italy (July 1934) was rejected by Luce, she briskly moved the artist along to his back-up idea. The original—a stylized scene of Mussolini in full salute viewed from behind, that Petruccelli later presumed was axed for being "undiplomatic"—was vastly superior to the wan piece of heraldry that ran, but Luce didn't like it. And Treacy was too much the realist to fight with Luce.

Yet with Ingersoll she fought, and fought some more. He was one of the great figures of American journalism: managing editor of *The New Yorker* at 25, editor and soon publisher of FORTUNE, publisher of *Time*, founder of the innovative New York daily *PM* (designed, as it happened, by T. M. Cleland). He was also a stern critic of both his colleagues and himself, and he habitually downgraded his own accomplishments and everyone else's. FORTUNE took the title to being the most beautiful magazine in the world "without effort," he wrote to Luce in

<hr />

*The one exception: dams. Late in the magazine's second year, Treacy wrote to an artist's agent, "I am sorry if I have not told you this before, but the whole subject of dams is completely taboo. I can't tell you just why, but I have had literally dozens of sketches in here, some of them very nice, with dams as the subject, and they have always been turned down. After all, there are only three things you can do with dams: look at them from upstream, downstream, or the air." Five years later, Margaret Bourke-White's photograph of the Fort Peck Dam in Montana—shot from upstream—would be the first cover of *Life*.

1935, "or much right." He saw its innovations, particularly its new style of industrial photography and its development of elaborately illustrated four-color maps, as "tricks."

Ingersoll, as much as Treacy, knew how critical the graphic elements were to the magazine's early success. He loathed studio portraits—no posed Bachrachs provided by a mogul's publicist for FORTUNE—considered the best 35-millimeter photographers to be true journalists, and never ceased pushing his staff to make better use of the huge canvas that was a two-page FORTUNE spread.

But he couldn't get Treacy to unlace the straitjacket of Cleland's formal design, and in his capacity as the magazine's publisher eventually wore her down. In 1938, by now married to Hodgins (who had succeeded Ingersoll as managing editor), Treacy found herself put on something like probation, ostensibly because of her maladministration of the art department.

After nearly nine years of six- and seven-day work weeks, she quit. In her letter of resignation to Luce, she wrote, "I will undoubtedly sniffle when I leave, but you'll just have to shrug at that, and mutter something about Women in Business." By 1940, Luce had stopped muttering and brought Treacy back to execute *Time*'s first redesign since its founding in 1923 (incidentally reuniting her with the former FORTUNE contributor Ernest Hamlin Baker, who would produce nearly 400 cover portraits for the newsweekly). In 1960 Treacy ran into Ingersoll, whom she hadn't seen in fifteen years. "I accused him again of being a son of a bitch," she said.

Her successor was Francis "Hank" Brennan, who took it as his job to move the magazine, both inside and out, in a somewhat modernist direction. Brennan's own June 1939 cover of a

steamship pipe was an eloquent representation of his aesthetic: boldly colored, only barely patterned, more poster than painting, it was a deft demonstration of sheer graphic power.

Like Treacy—like all first-rate art directors—Brennan believed in the talent. The Italian émigré George Giusti, whose work first appeared on the cover in February 1941, said more than four decades later that "FORTUNE gave me total freedom. Most of the time I did not submit sketches—I delivered the final work." Brennan encouraged Fernand Léger's stunning exercise in industrial symbolism (December 1941); he led the Mexican-born caricaturist Miguel Covarrubias to experiment with a more documentary style (October 1938); and he worked with the editors to begin to tie cover subjects to a story—often the most important story—featured inside, a practice that had become all but universal in the American magazine industry.

But Brennan's most radical act was the commissioning of an Otto Hagel photograph of an airplane tail for the April 1940 cover. Highly graphic, almost painterly in both composition and coloring, the Hagel was new not merely for its being a photograph. It prefigured as well the stunning chronicle of World War II that would play out on the FORTUNE covers over the next five years.

Brennan: He chronicled the war on the magazine's cover.

First under Brennan and his assistant Peter Piening, then more aggressively under Piening himself when he succeeded to the head job in the summer of 1942, the FORTUNE covers of the war

years, especially 1941–1943, are more than a vivid record of ships and planes and armaments (although they are definitely that). Looking at Petruccelli's stately rows of military tents (May 1941), Giusti's torpedo and airplane (August 1942), Herbert Bayer's tableau of the means of production (February 1943), or Rudy Arnold's "Invasion Tactics" (March 1944), you see Brennan and Piening deploying a vocabulary of heroic iconography, a series of signals that identified the magazine with the war and the war with a higher nobility. It was a glorious, muscular form of propaganda, and all the more effective because it didn't stoop to cliché. Consider FORTUNE's special issue on Japan and the Japanese (April 1944), published in the midst of the brutal island-to-island campaign in the South Pacific: in most American magazines of the day, the temptation to racial stereotyping or some other form of lurid demonology would have been irresistible. But Piening—himself a refugee from the Nazis— thought to hire the exiled children's book illustrator Taro Yashima. Together they produced a cover that was close to perfect, somehow both quiet and bold, an instant icon.

Piening alone created half the covers in 1944, acting as both illustrator and art director. Although he was capable of fine work, his covers simply don't have the aspirations of those he commissioned from others. It must have been an unhappy time for him, cut off from easy collegiality by his very limited English, forced into double duty by the wartime talent shortage. But by Piening's own admission he was difficult to work with— "a bastard," he said—and his defection to the world of industrial design probably came at the right time: with the war's end, FORTUNE—on the cover, on the inside pages, in its very corridors—was about to change.

The postwar boom, the war-assisted consolidation of the American corporation's economic hegemony, the simple fact of Henry Luce getting older and richer—

change was as certain as FORTUNE's undisputed eminence among American business magazines. The new art director, Will Burtin—like Piening, a German refugee—turned to new (if no less capable) artists, among them Gyorgy Kepes, Dong Kingman, Robert Gwathmey and Ben Shahn; he accelerated the use of photographs; he found new and effective ways to make a graphic splash on the smaller canvas that had come into being in March of 1943, when wartime paper shortages brought about a reduction in the magazine's footprint (roughly one inch was lopped off both the height and the width).

But mostly it was Luce's attitude that changed. By 1948, there was no question where the founder's affinities lay, or that the magazine's own success was inextricable from the success of American industry itself. Now, he said, he wanted "a magazine with a mission . . . to assist in the successful development of American business enterprise at home and abroad."

This didn't mean the end of handsome art on the cover or inside the pages of FORTUNE, but it did signal that the magazine was no longer the lavishly outfitted playground for brilliant writers and editors who didn't care much about business. Now the magazine was thoroughly professionalized.

As, of course, it had to be if it wished to survive the competitive buffeting of the last half of the century, when television took over so large a chunk of the average reader's time, when specialization brought forth niche magazines that nibbled painfully—sometimes fatally—at the heels of the old giants, when newspapers became more mindful of the sound of their prose and the look of their pages. As competitive institutions shed their old, limiting formulas and moved toward FORTUNE's turf, FORTUNE had to jettison the formula that had shaped its own beginning: the one of sheer, indulgent luxury—of prose, of art, of physical opulence—that had made it the grandest magazine America would ever know.

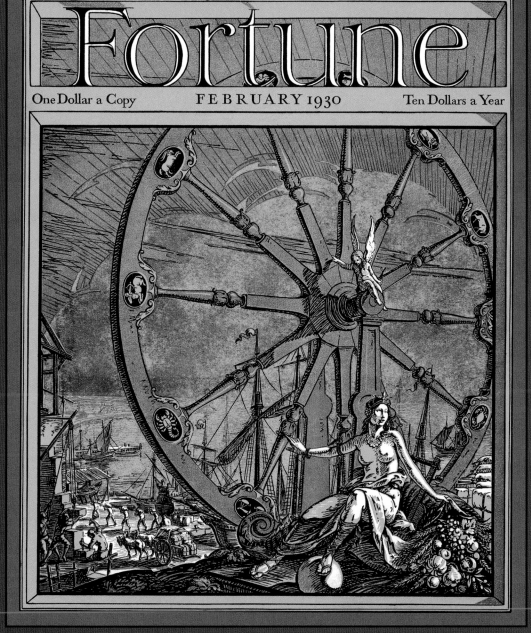

One Dollar a Copy FEBRUARY 1930 Ten Dollars a Year

T. M. Cleland

- *Great Depression triggers worldwide economic crisis*
- *Massachusetts Institute of Technology builds first large-scale analog computer*
- *Wonder Bread introduces packaged presliced bread*

U.S. GNP
Billions

$90.4

U.S. INCOME
Per Capita

$625.00

UNEMPLOYMENT
Yearly Average

8.7%

FROM FEBRUARY 1930: *Billions*

Fifty years ago a man made his hundred thousand. A generation ago he made his million. Now a few of them have made, or are about to make, or are generally said to be about to make, their billion. A billion has become a possible fortune.

And yet no man has ever identified a billion with his eyes. Even in hard cash a billion is invisible. There are not five billion cash dollars in the whole United States and a billionaire is a creature of faith like an angel for no billionaire could liquidate for a billion. . . . Perhaps the most effective way of realizing the dimensions of a billion dollars is to make it.

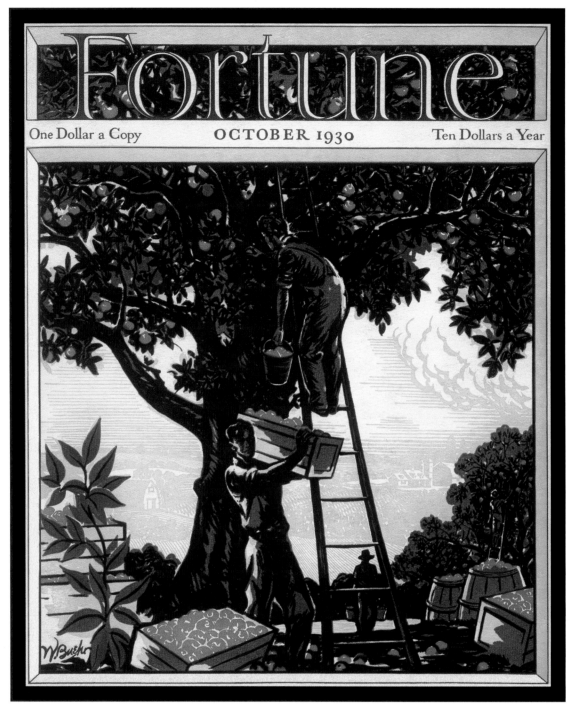

Walter Buehr

FROM OCTOBER 1930: *Color and Sound on Film*

It was by the invention of the motion picture that Science for the first time in the world's history directly affected drama. . . . The only trouble with Science is that it does not know how or where to stop. We were no sooner beginning to master the technique of this new and universal art than Showmanship saw a way to exploit what Science had had available for several years—the crude elements of photographic spoken drama. And now, with the talkie still in its infancy, both technically and artistically, comes the exploitation of color, while from around the corner falls the shadow of Television.

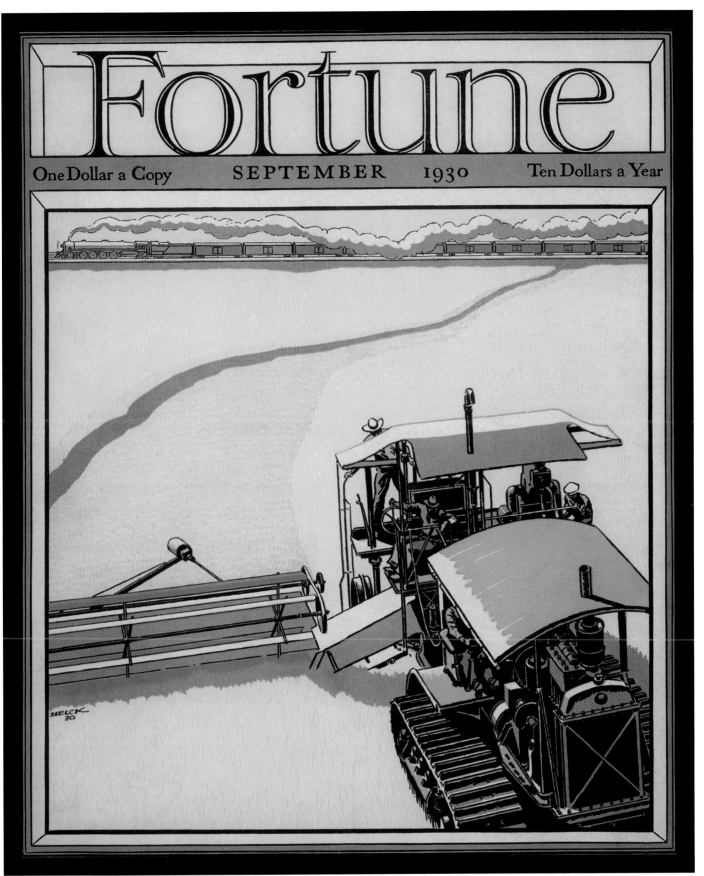

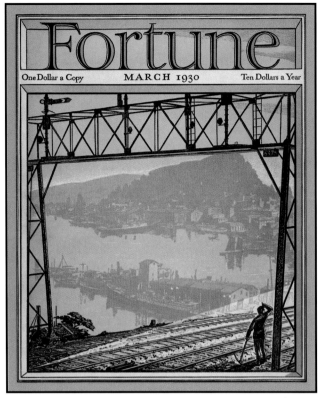

Artist unknown

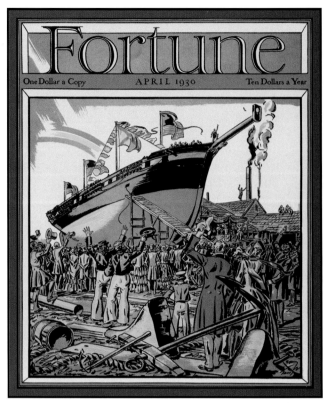

Artist unknown

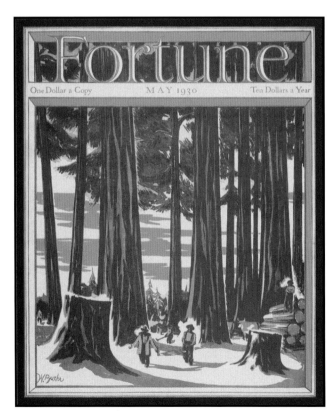

Walter Buehr

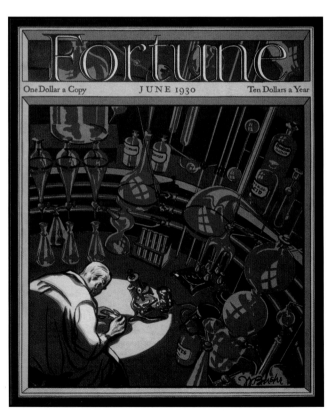

Walter Buehr

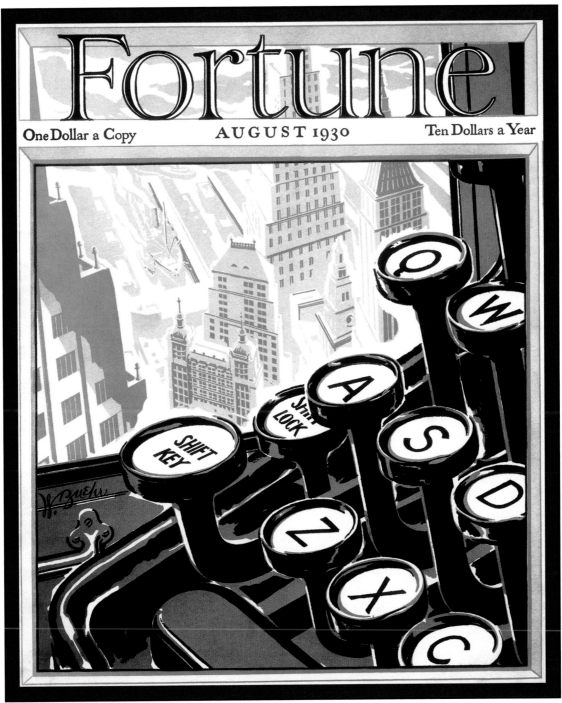

Walter Buehr

FROM AUGUST 1930: *Skyscrapers: Pyramids in Steel & Stock*

All a man needs, to own a skyscraper, is the money and the land. And he may be able to get along without the money.

But since there is no known substitute for the land and no satisfactory legal device by which the investing public can be induced to bring its own, the [building] promoter must secure the land. And its acquisition is not easy. Land capable of producing skyscrapers and keeping them green is as limited in quantity as it is unlimited in price.

Artist unknown

Charles Dewey

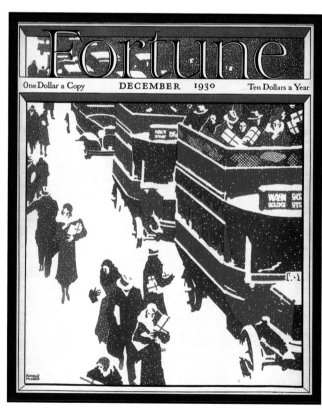

Ronald McLeod

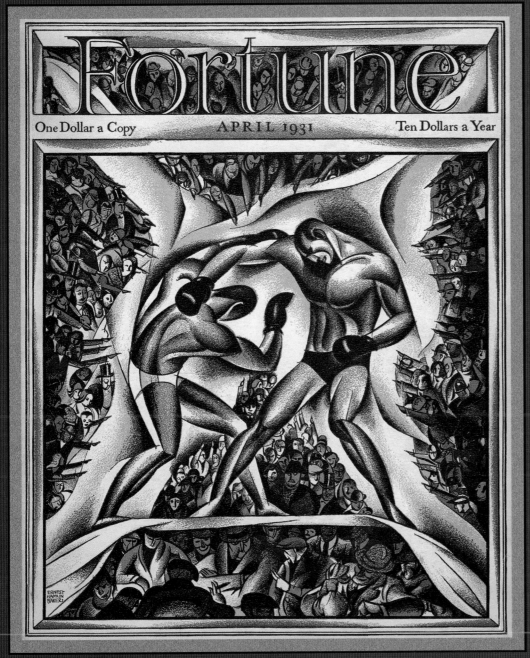

One Dollar a Copy APRIL 1931 Ten Dollars a Year

1931

- *Hundreds of banks fail as depositors withdraw savings*
- *George Washington Bridge opens, connecting New York and New Jersey*
- *Dick Tracy comic strip premiers in newspapers*

U.S. GNP
(Billions)

$75.8

U.S. INCOME
Per Capita

$531.00

UNEMPLOYMENT
Yearly Average

15.9%

Ernest Hamlin Baker

FROM APRIL 1931: *Bond Fire*

A casual rambler about a big bank would probably be startled to come across a long pink sheet headed, in gruesome boldface type, "CREMATION CERTIFICATE." But he would be reassured to read through the rest of the heading, an impressively formal: "This is to certify, that we, the undersigned, have this day in the presence of each other destroyed the following securities by burning same to ashes."

The actual burning isn't very exciting. The witnesses take turns poking at the fire or throwing the small bundles of bonds in, watch the embers dreamily or sleepily, and yawn prodigiously. The excitement is all in the furnace, and it is a curiously fitting end for the heavily engraved papers which built mills, fashioned turbines, or sent mile after mile of cool gray rail over wide plains.

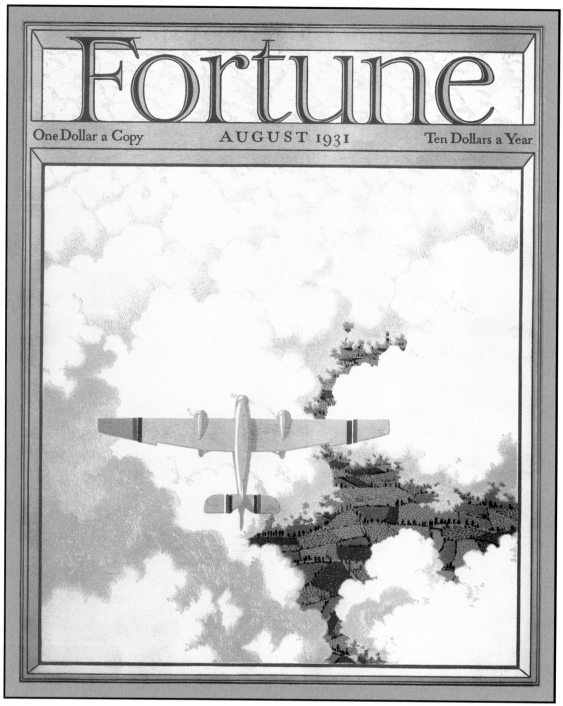

Fortune

One Dollar a Copy AUGUST 1931 Ten Dollars a Year

Edwin A. Georgi

FROM AUGUST 1931: *How to Live on $7 a Day at 2817½ Amazon Avenue . . .*

 The old working-class budget used to read like a working-class budget. But the Gurty [family] budget reads like something else. It enters *motion pictures, plays, travel, newspapers, magazines, music lessons, tobacco, toilet articles and toilet preparations, a telephone and a car.* The amounts are, it is true, exceedingly small. But the meaning is easy enough to read. The Gurtys aren't "workers" in the social propaganda sense of the term. They are *petit bourgeois* in their desires and middle class in their interests. And that fact is perhaps of more significance to an estimate of the American scene than any other about them.

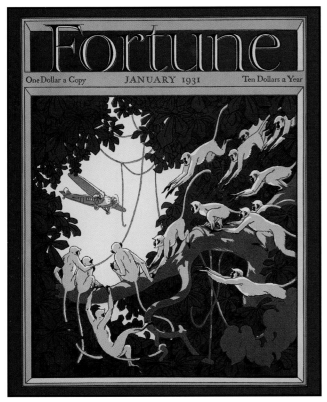

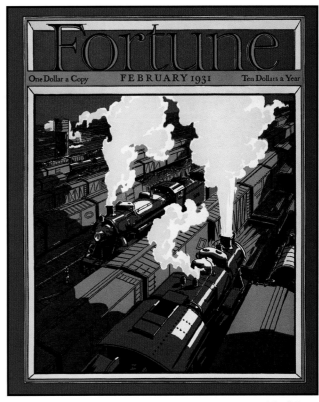

Neal Bose

Neal Bose

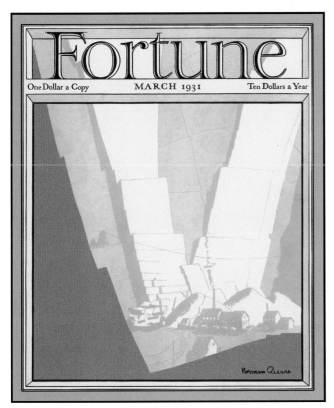

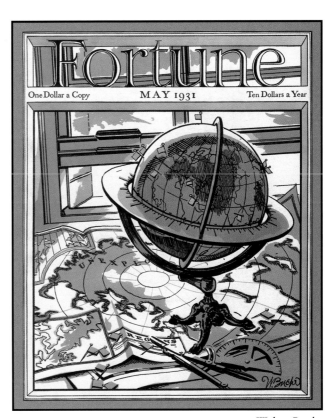

Norman Reeves

Walter Buehr

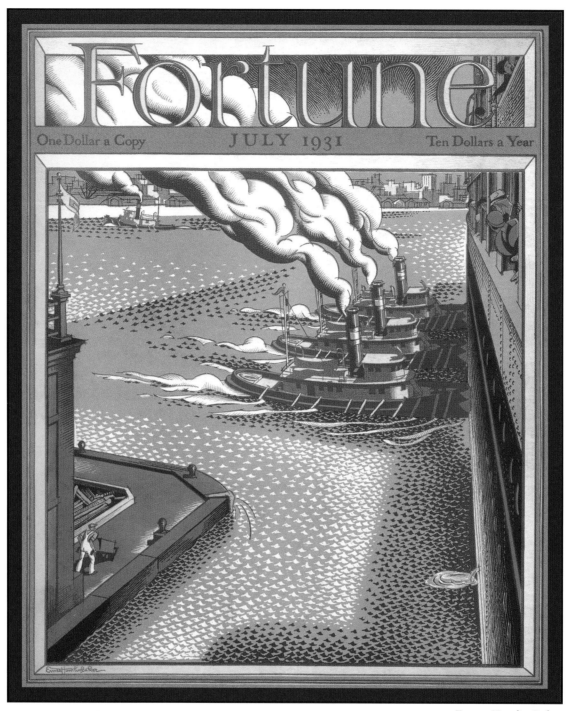

Ernest Hamlin Baker

FROM JULY 1931: *U.S. Dollars Abroad*

Very generally speaking, it may simply be said that foreign investments are characterized by greater risks and greater profits, and that the present conditions of world economics, of course, emphasizes the possible loss and minimizes the potential gain. It should always be remembered, however, that our foreign investments, consolidated, are no larger than a combination of a dozen of our largest domestic corporations, and less than four times as large as one domestic corporation (American Telephone & Telegraph) alone, so that we can hardly be said to have an undue proportion of our eggs in the foreign basket.

Fred Ludekens

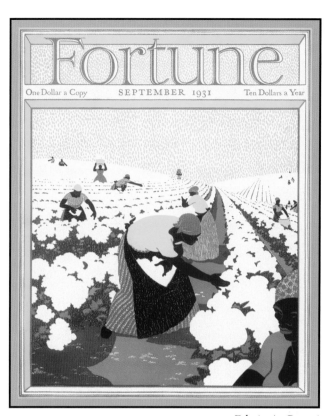

Edwin A. Georgi

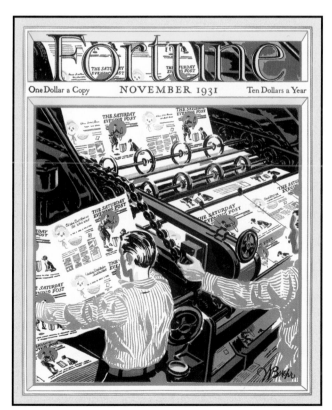

Walter Buehr

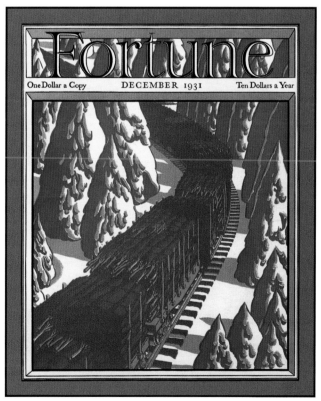

Ernest Hamlin Baker

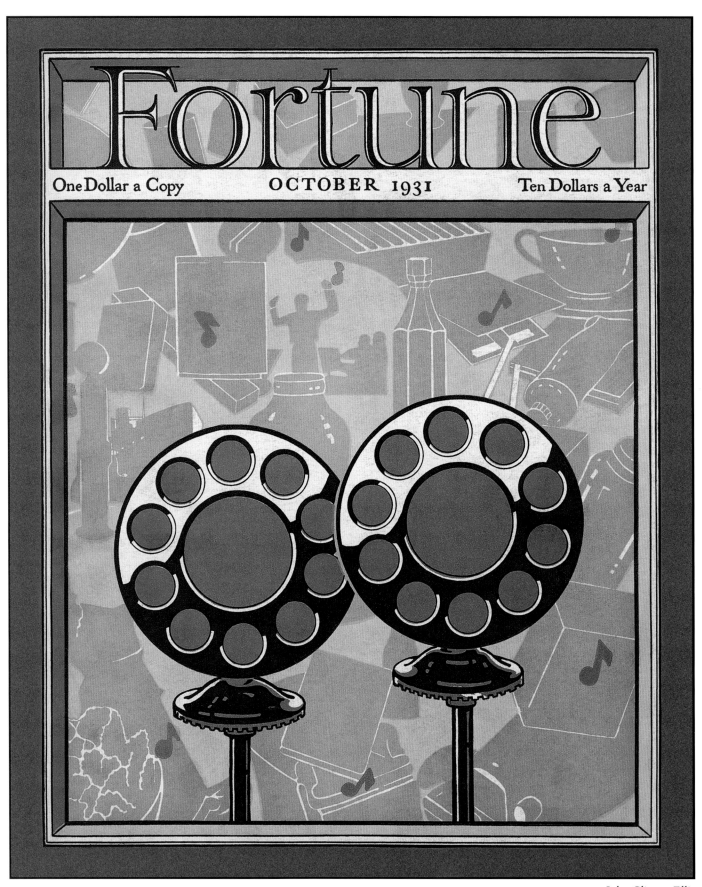

Fortune

One Dollar a Copy OCTOBER 1931 Ten Dollars a Year

John Clinton Ellis

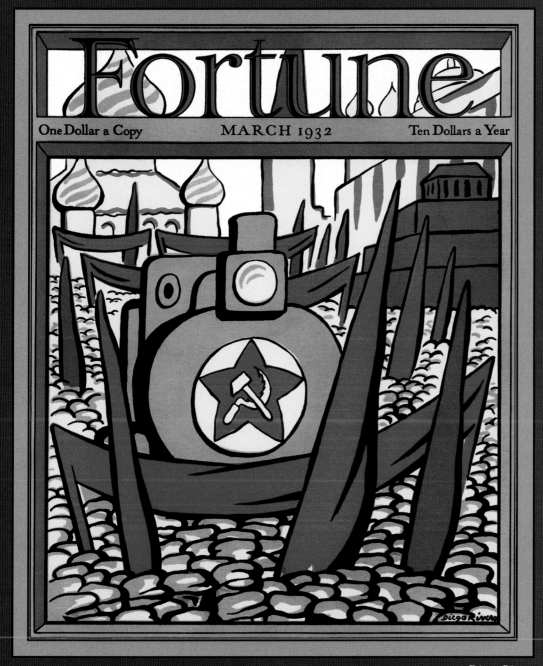

1932

• Franklin D. Roosevelt elected 32nd president of the U.S.
• Charles Lindbergh's son is kidnapped in New Jersey
• Los Angeles hosts the Summer Olympic Games

U.S. GNP
Billions
$58.0

U.S. INCOME
Per Capita
$401.00

UNEMPLOYMENT
Yearly Average
23.6%

Diego Rivera

FROM MARCH 1932: *The Eternal Peasant*

Nothing in contemporary Russia is more interesting or significant for the future than the change in the Russian peasant which the increasing success of collectivization is producing. . . . As the peasants have been induced to join the collectives, a change in attitude has appeared. They find themselves for the first time on the way to becoming an economic and therefore political power. Where, previously, the complaints of a single peasant were merely disregarded and his grain seized, now the complaints of a thousand peasants banded together in a great collective are at least heard . . . now his interests are recognized, the price differential is narrowed, and the State concerns itself more and more with his well being.

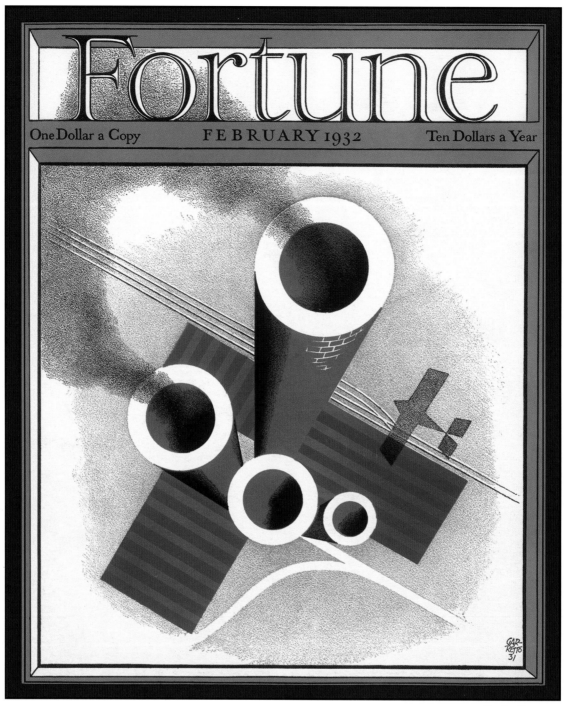

Paolo Garretto

FROM FEBRUARY 1932: *The Great American Salesman*

Alfalfa forks, burglar alarms, daffodils, and freckle creams; guest towels, plasterers' hawks, and ham protectors; wagon hounds, tinsel icicles, and mailmen's socks; house numbers, ouija boards, and pretzels; referees' whistles, rosaries, and rosin; animal scents, back scratchers, ship models, toboggans, and trouble lamps; votive candles, calf weaners, bridal wreaths, yarn, yeast, and zigzag rules.

These are only a few of the 48,000 items offered twice yearly to 7,000,000 families by the Sears, Roebuck Catalogue—the Great American Salesman.

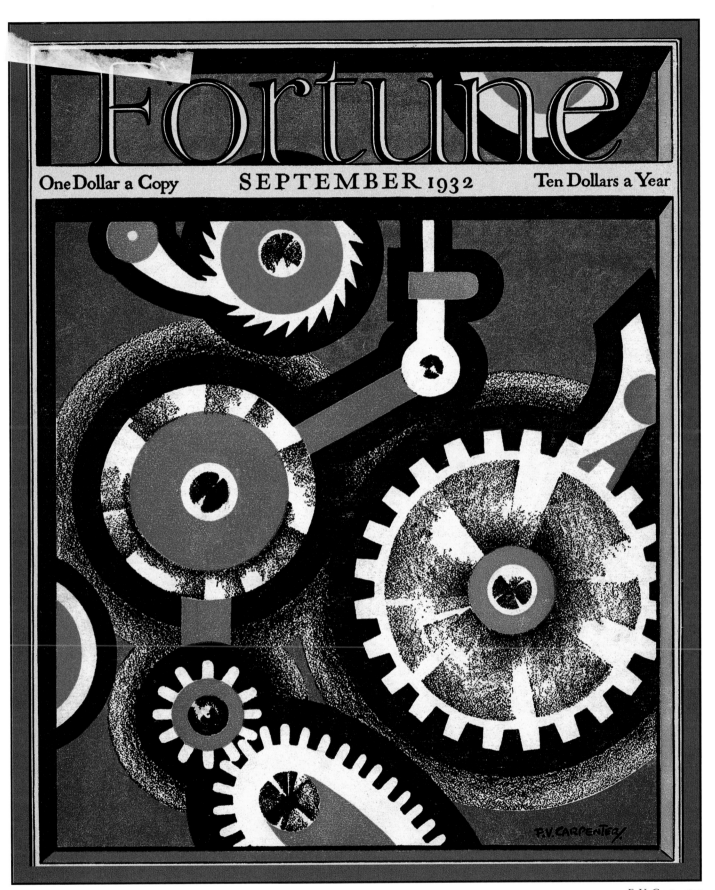

One Dollar a Copy SEPTEMBER 1932 Ten Dollars a Year

F. V. Carpenter

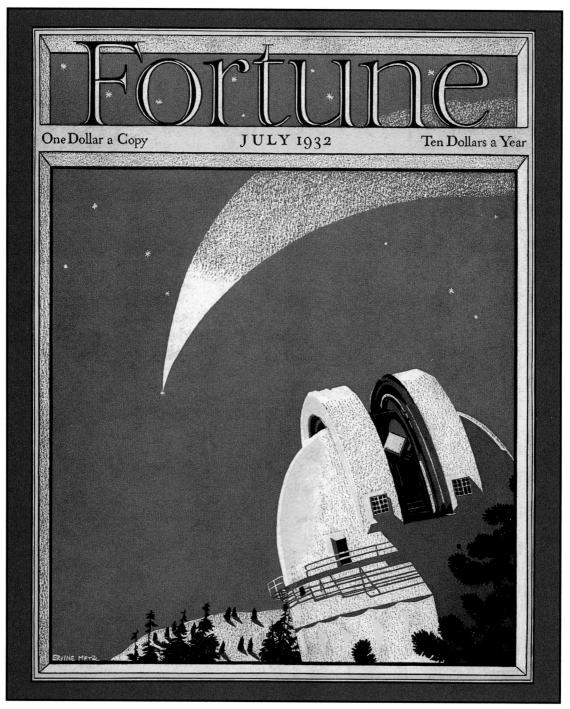

Ervine Metzl

FROM JULY 1932: *The New Cosmology*

[Albert Einstein] has seized the imagination of the civilized world. . . . Newspapers have acclaimed him as a 20th century hero. He himself has said: "Relativity has nothing to do with the soul; it is matter only for the head." Yet the popular versions of relativity have a great deal to do with the soul; they constitute a kind of weird mythology in which Dr. Einstein is cast in the role of Hercules performing the twelve incredible labors. Indeed, this humble though versatile doctor of philosophy has become, in the American mind, a superman-of-science; the essential difference between him and the Greek demigod being that no one has the slightest idea what his twelve labors have been.

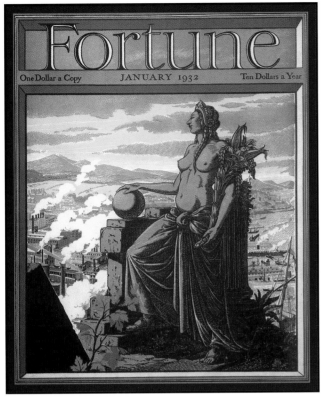

T. M. Cleland

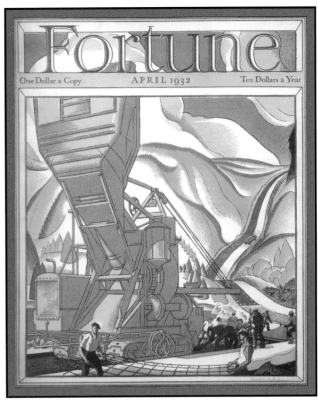

Ernest Hamlin Baker

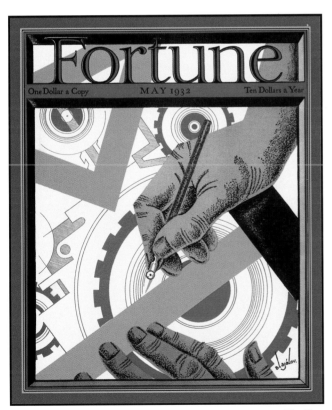

Constantin Alajálov

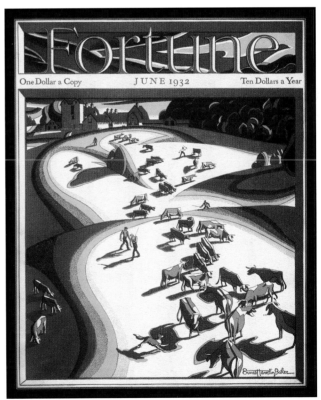

Ernest Hamlin Baker

33

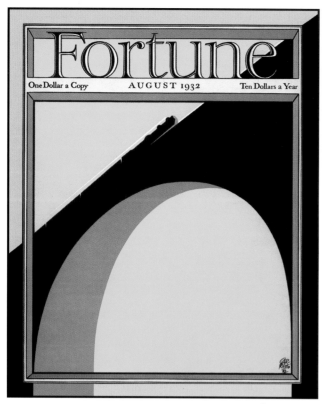

Paolo Garretto

A. C. Webb

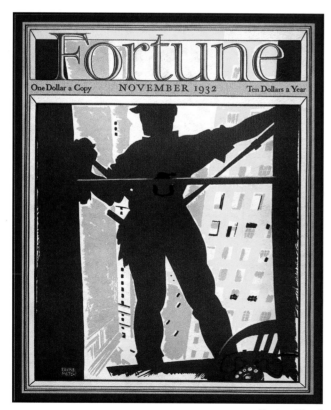

Ervine Metzl

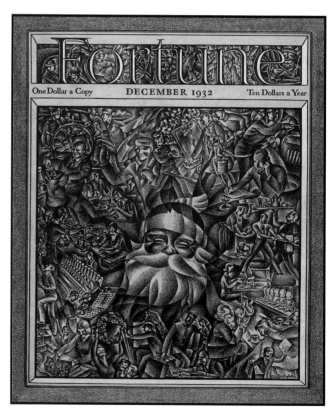

Ernest Hamlin Baker

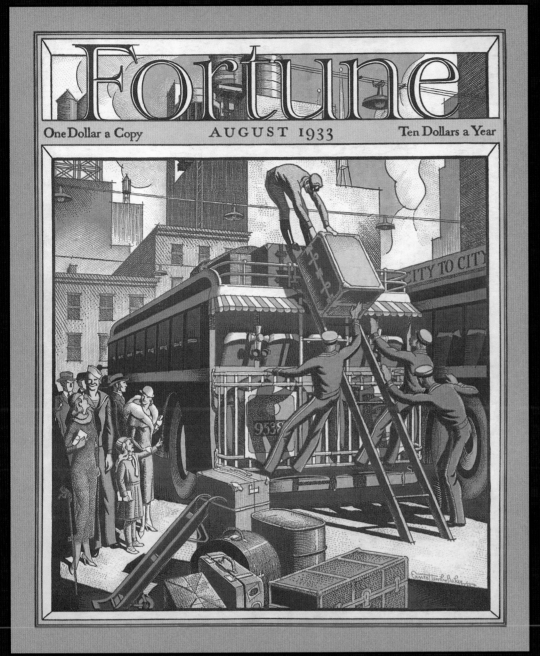

1933

Ernest Hamlin Baker

FROM AUGUST 1933: *Introducing Duke Ellington*

Ellington hates the spade work of writing music. At rehearsals, which are frequently called for three o'clock in the morning, after the night's work is done, no scores are visible. The leader seats himself at the piano and runs over the theme he wishes to develop, shows the men what he thinks the saxophones might play here and the brasses there. Perhaps Barney Bigard, the solo clarinetist, suggests a rolling phrase on the reeds at a certain point; it is tried and judged by general opinion. . . . Each man has his say. After four to five hours of this informal process, a new number has been perfected.

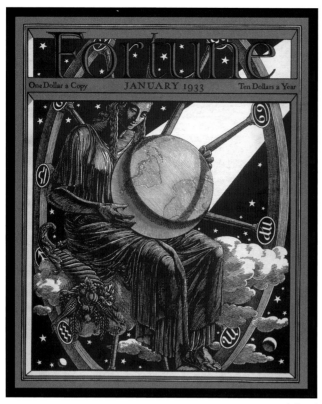

T. M. Cleland

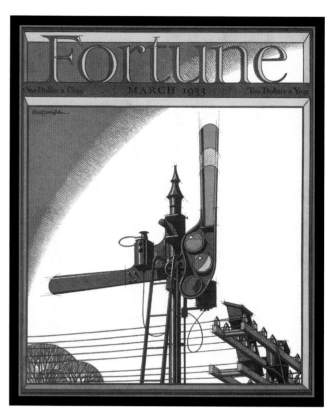

Ernest Hamlin Baker

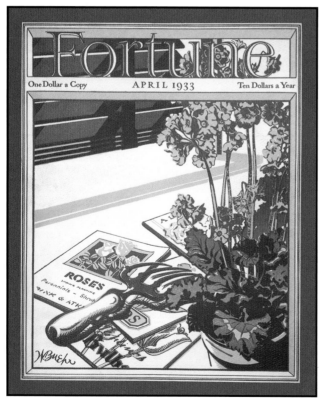

Walter Buehr

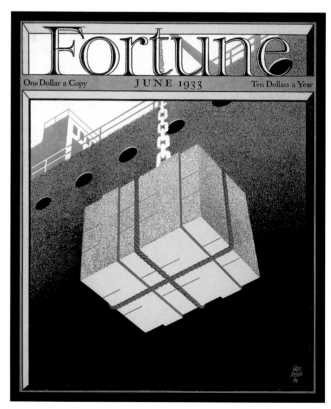

Paolo Garretto

36

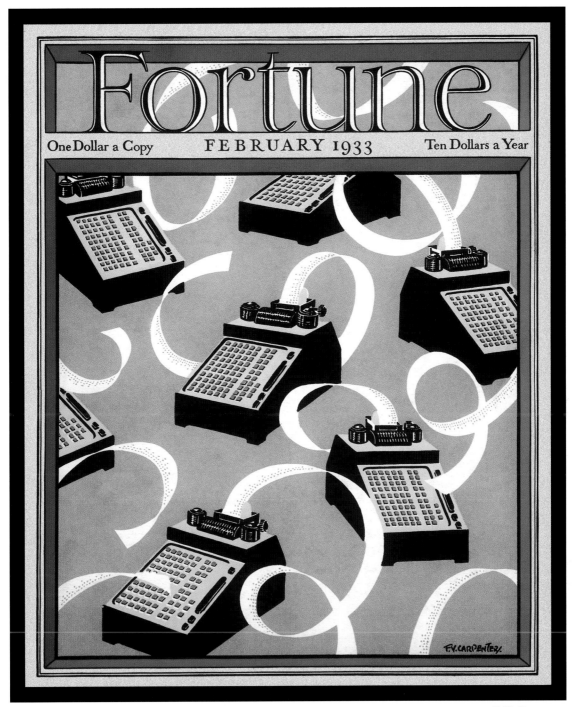

One Dollar a Copy FEBRUARY 1933 Ten Dollars a Year

F. V. Carpenter

FROM FEBRUARY 1933: *200,000 Wandering Boys*

Newspapers and Sunday supplements have recently printed foreboding stories about a vast, homeless horde of boys wandering through the U.S., a pallid army of amateur hobos—Another Result of the Depression.

There are at least 200,000 wandering boys in the U.S. For instance, some 6,000 men, three-quarters of them under twenty-one, steal rides on the Southern Pacific every month. They are young boys. Practically all of them are obviously home-bred, with grammar or high-school education—boys such as you might see in any school yard.

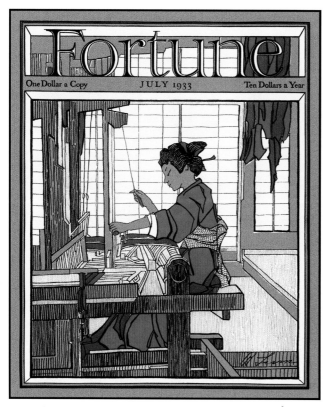

Bertha Lum

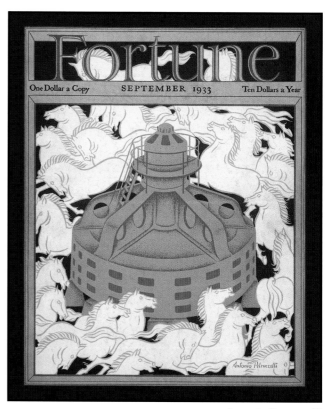

Antonio Petruccelli

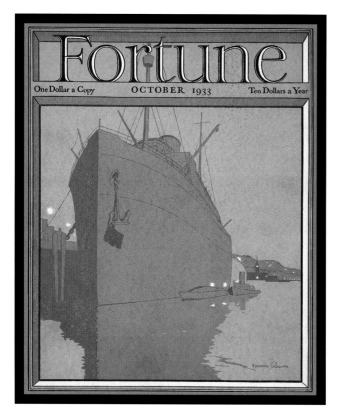

Norman Reeves

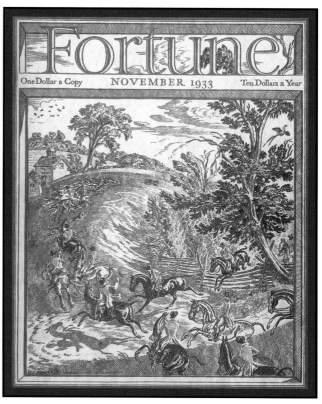

Robert Ball

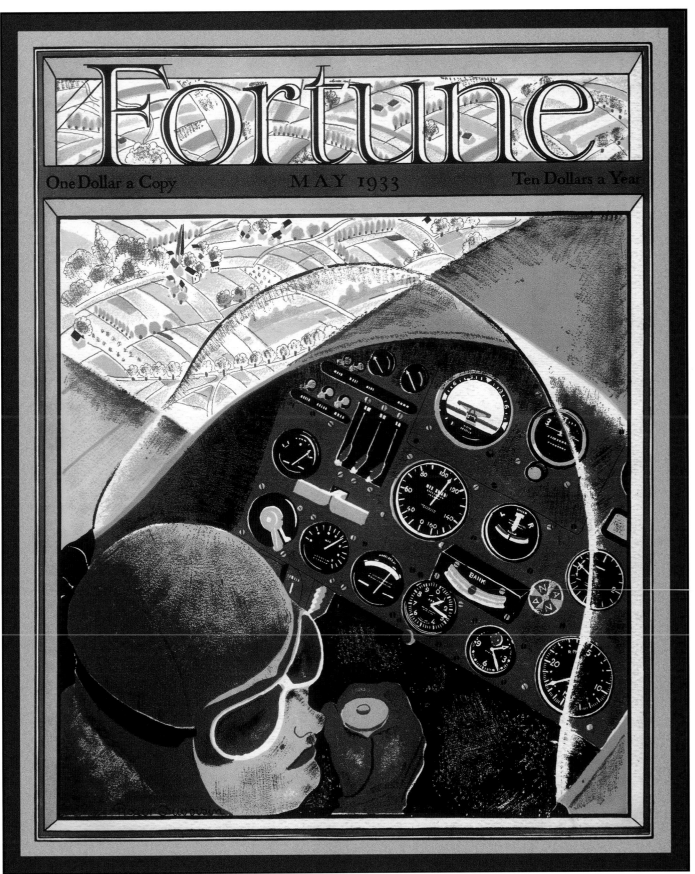

One Dollar a Copy MAY 1933 Ten Dollars a Year

Roger Duvoisin

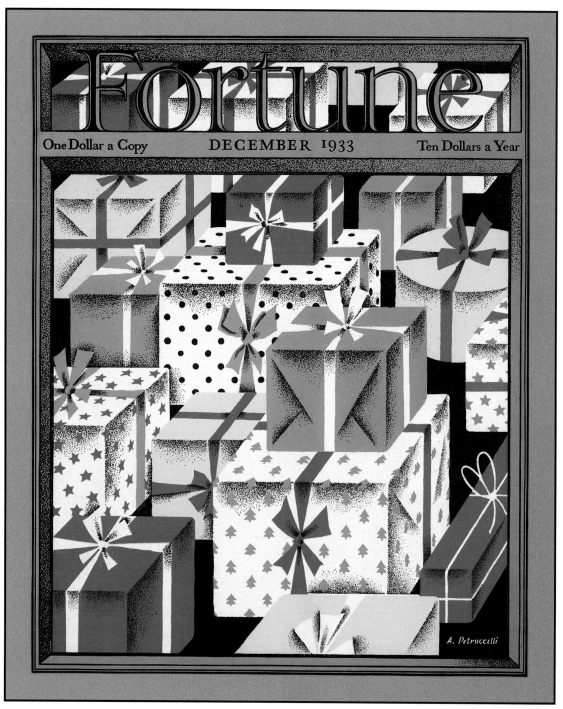

Antonio Petruccelli

FROM DECEMBER 1933: *The Dressmakers of the U.S.*

It is curious, when you stop to think of it, that the 45,000,000 women of the U.S. should depend on Paris for the style of their clothing. Paris is three thousand miles of ocean away and inhabited by a race of strikingly different temperament. . . . What is the secret? To what maturity must the adolescent U.S. *couture* aspire? In general, before it can call itself the style center of the world it must achieve four things: the finest ideas, the finest material, the finest workmanship, and the loudest ballyhoo—never forget the loudest ballyhoo.

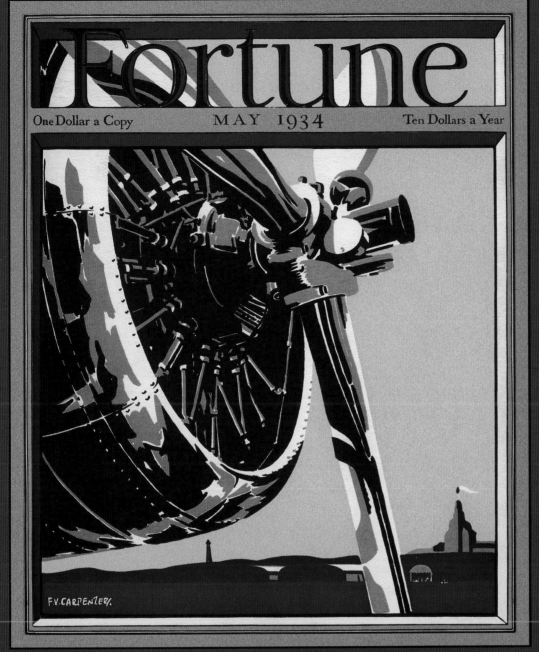

1934

• *The Dust Bowl engulfs Oklahoma and the Dakotas*
• *F. Scott Fitzgerald's* Tender is the Night *is published*
• *Public Enemy No. 1, John Dillinger, is shot and killed by FBI*

U.S. GNP
Billions
$65.1

U.S. INCOME
Per Capita
$427.00

UNEMPLOYMENT
Yearly Average
21.7%

F. V. Carpenter

FROM MAY 1934: *Federal Reserve*

The Roosevelt Revolution has not taken place in industry [nor] in agriculture. But the Roosevelt Revolution has nevertheless taken place. And the place is . . . the country's credit system. While the journalists and the captains of industry have kept their eyes riveted to the sacred institution of private property (which was never in danger) and the so-called price system (which was never threatened) and the freedom of the press (which was as safe as the state of Pennsylvania) the Administration has quietly and efficiently carried forward a revolution at the heart of the capitalistic order which may have the most profound effect upon the future of the American economy. It has changed the control of credit from a theoretically automatic and thermostatic control exerted by one of the cleverest mechanisms of the age to an intentional and volitional control exerted by the human hand.

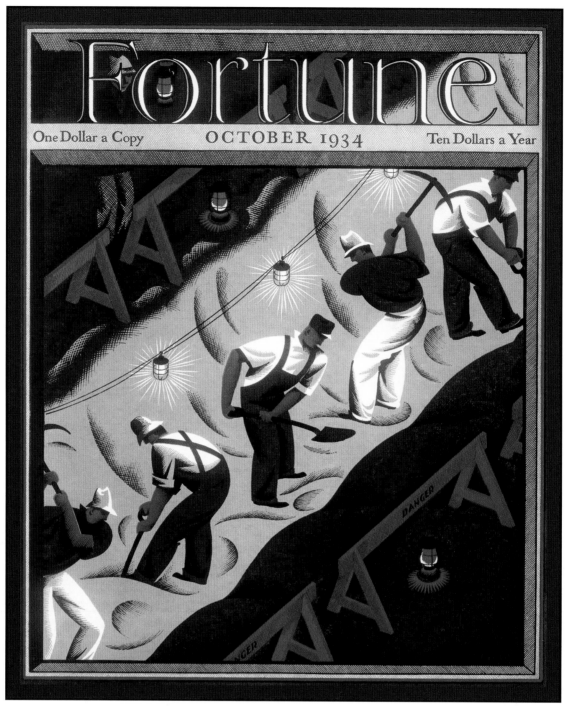

FROM OCTOBER 1934: *"The Worst, Most Ruinous, Costliest" Drought in U.S. History*

Roundabout the first of May, 1933, in many parts of the Dakotas, it quit raining, and the barbecue began. Last winter's light snowfalls brought a crop of winter wheat which wrung the earth quite dry. Last spring, in those parts, was the driest on record. And with last summer's sun enlarging on the ruthless sky, the brown scorch spread swiftly, as when a cigarette is left to burn on dry paper. By the middle of last August a good third of our part of the continent was one wide crisp.

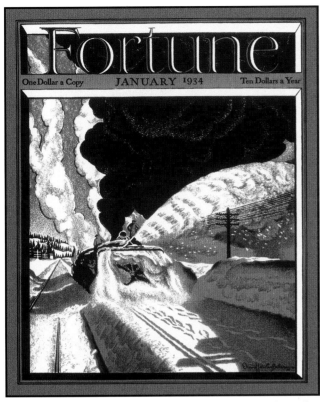

Ernest Hamlin Baker

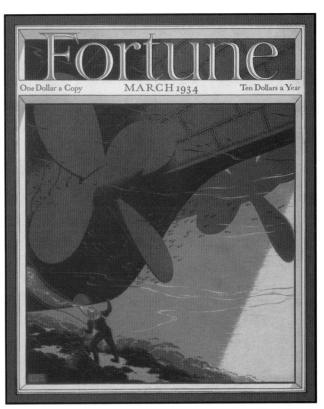

Victor Beals

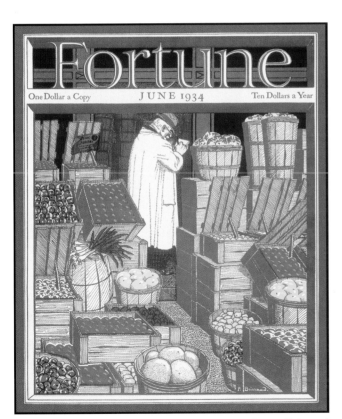

Pierre Brissaud

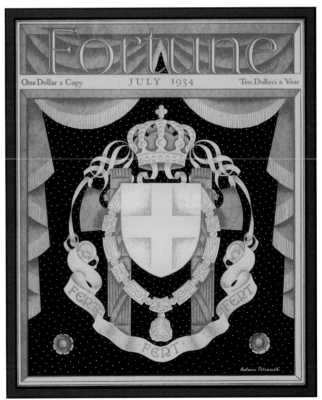

Antonio Petruccelli

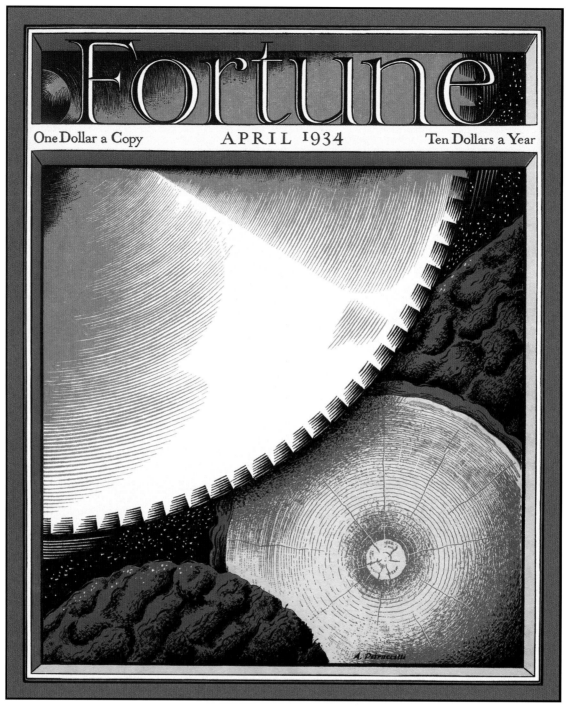

Antonio Petruccelli

FROM APRIL 1934: *Dollars from Wood*

There are, classically, two ways to make money in this lumber business, and two only, and one of them is obsolete. That was the way of the lumber barons. . . . It was to buy timberland, always more and more land, and to hold it until it sugared off. But the Northwest was the last frontier. The second way is less spectacular; it is the way of smaller men, but men whose knowledge contains a little geometry, a little engineering, and a great deal of common sense. It consists of knowing the best "logging chance" and taking it, and of getting the most inches of the best lumber out of every log.

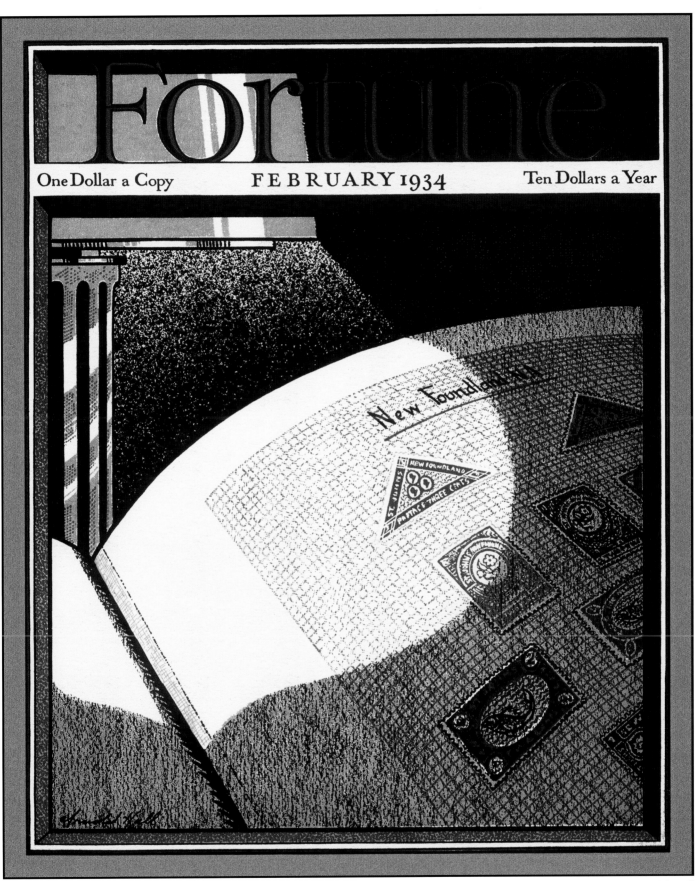

One Dollar a Copy — FEBRUARY 1934 — Ten Dollars a Year

Arnold Hall

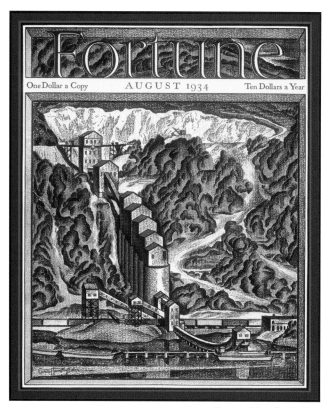

Ernest Hamlin Baker

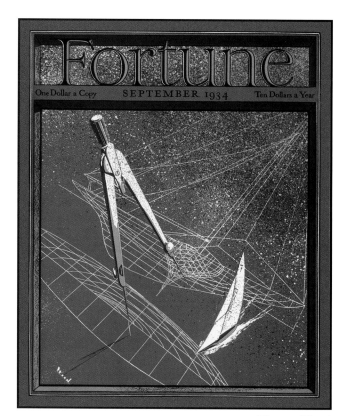

Thomas Wood

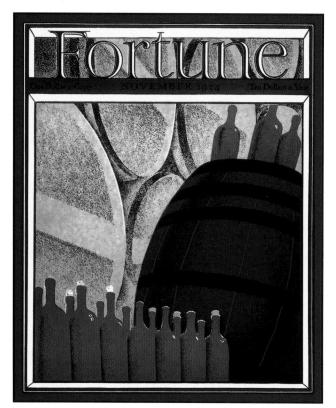

Roger Duvoisin

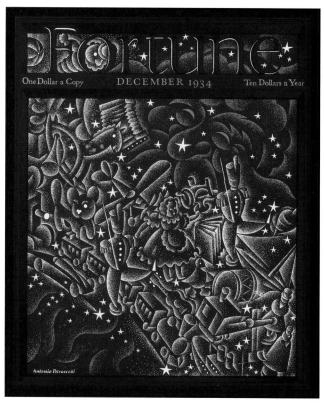

Antonio Petruccelli

46

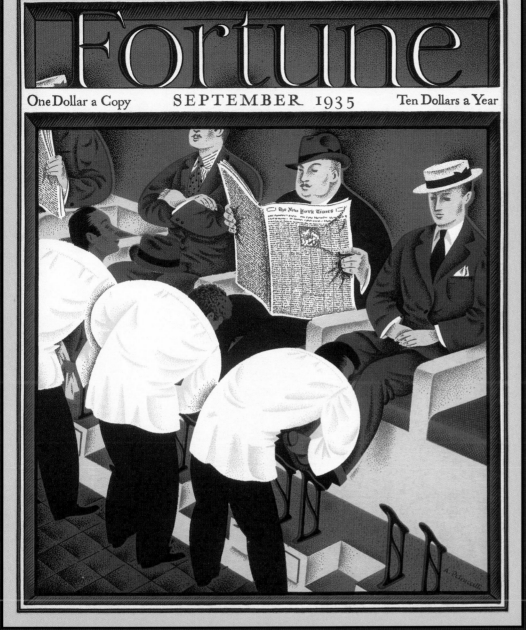

1935

• Social Security Act provides for unemployment, retirement, and welfare benefits
• Parker Brothers introduces the Monopoly board game
• Alcoholics Anonymous is founded in New York

U.S. GNP
Billions

$72.2

U.S. INCOME
Per Capita

$474.00

UNEMPLOYMENT
Yearly Average

20.1%

Antonio Petruccelli

FROM SEPTEMBER 1935: *500 Corner Drugstores*

Elaborate preparations have to be made whenever a new Walgreen store is to be opened. After a city has been chosen (for its retail sales and drug sales volume) the area in which the store will stand depends on where the traffic is heaviest. That it will stand on a corner is inevitable. But which of the four corners at an intersection? Squads of surveyors take up unobtrusive stations on all the four corners and count the passers-by. They make four counts a day: in the morning from ten-thirty to eleven-thirty, in the afternoon from two-thirty to three-thirty, in the evening from five to six, and for the night business from eight to nine. The count may go on for as long as a week. Only women and men over sixteen are counted.

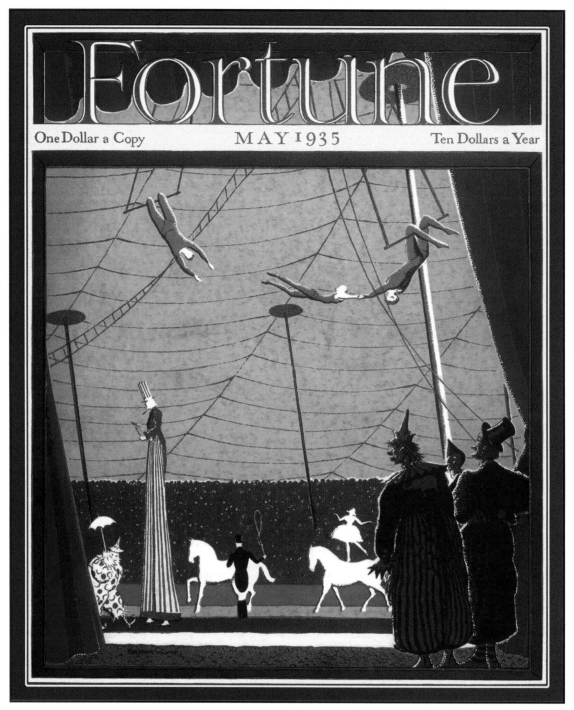

Norman Reeves

FROM MAY 1935: *New York Pushcarts*

New York's 12,000 pushcart merchants are not in the least interested in the fact that they help solve a difficult problem of modern distribution. They have a living to make and they work hard, fourteen hours a day or more, for their small profits. . . . If the pushcart man buys shrewdly, bargains tenaciously (which he must or he won't last long), he should make $15 a week. This estimate, of course, he will deny with his last breath, swearing invariably that he has been losing money for years.

48

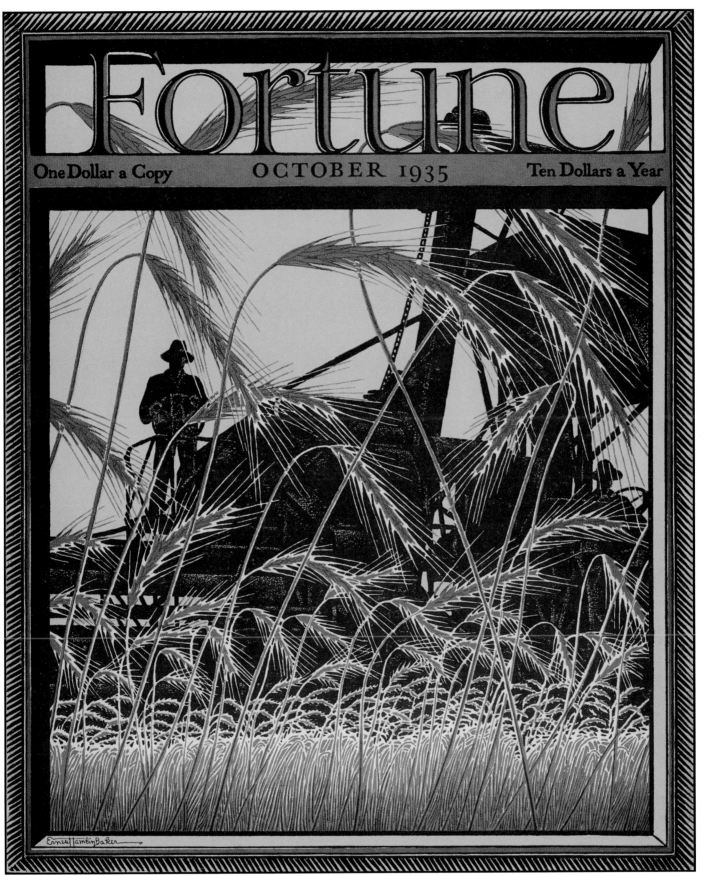

Fortune

One Dollar a Copy OCTOBER 1935 Ten Dollars a Year

Ernest Hamlin Baker

49

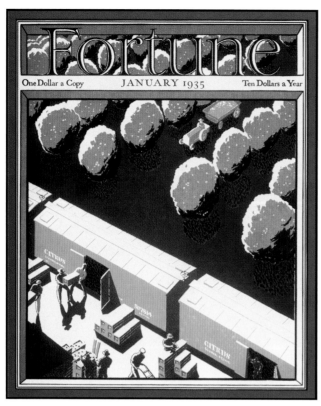

Norman Reeves

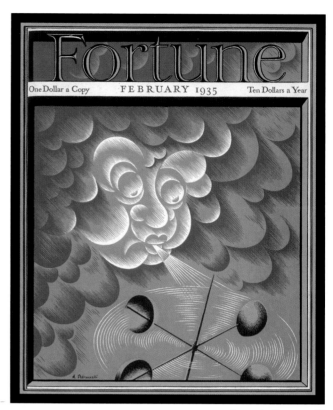

Antonio Petruccelli

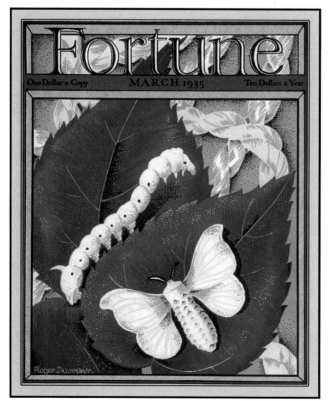

Roger Duvoisin

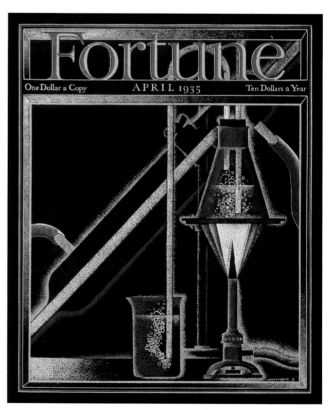

John O'Hara Cosgrave II

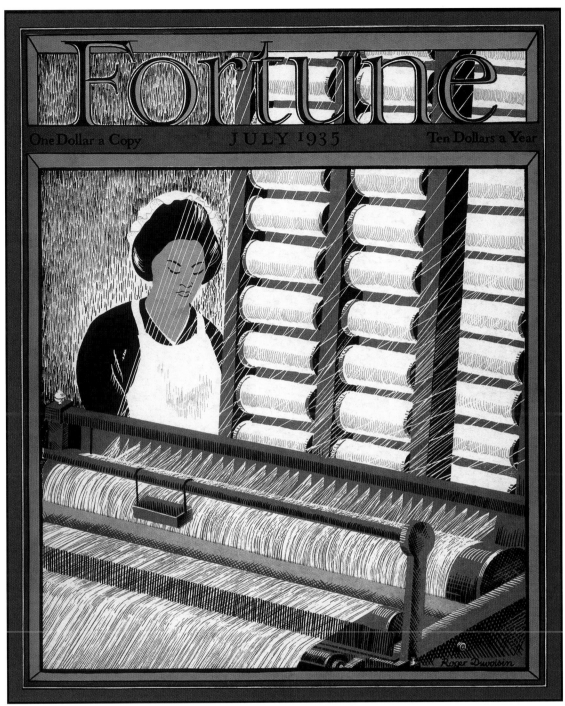

One Dollar a Copy — JULY 1935 — Ten Dollars a Year

Roger Duvoisin

FROM JULY 1935: *Women In Business*

There is a case to be made for the proposition that women made American business what it became in the nineteen twenties: the closest approximation to an art that this industrial civilization has produced. The case would rest, not on the female executive who, however scintillating individually, has yet to move the earth, but on the women in the humbler roles in business: on the feminization of the American office. Such a case would suggest that a synchronization of man's creative ability with woman's efficiency with detail made the wheels of commerce turn more smoothly and enabled us to outslick our competitors.

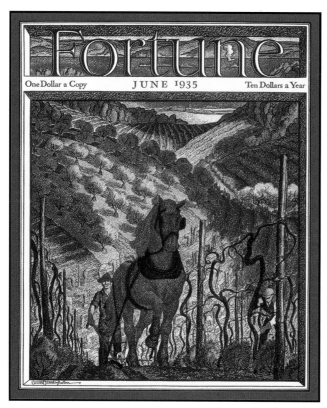

Ernest Hamlin Baker

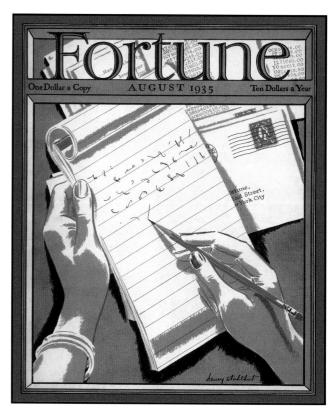

Henry J. Stahlhut

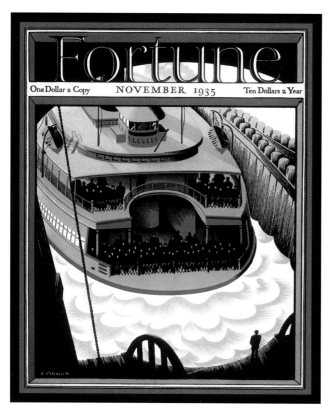

Antonio Petruccelli

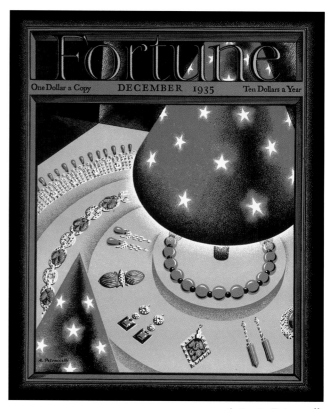

Antonio Petruccelli

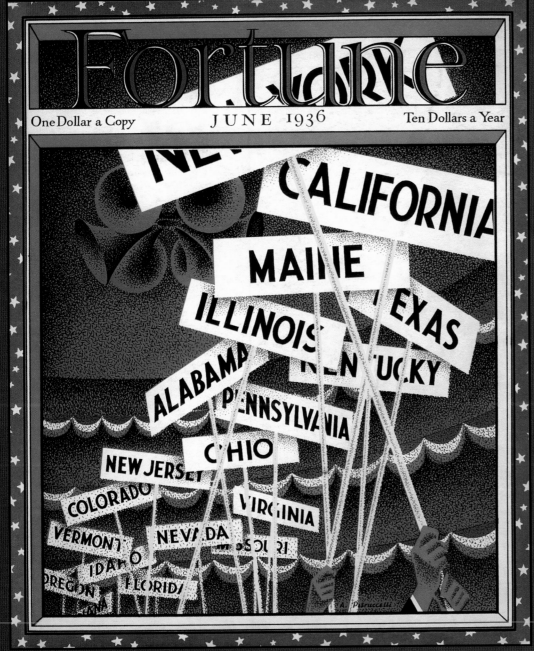

Antonio Petruccelli

1936

• *Spanish Civil War begins*
• *President Roosevelt re-elected for a second term*
• *Margaret Mitchell's Gone with the Wind is published*

U.S. GNP
Billions
$82.5

U.S. INCOME
Per Capita
$535.00

UNEMPLOYMENT
Yearly Average
16.9%

FROM JUNE 1936: *Youth in College*

"Not to eat, not for love, but only gliding." This Emersonian phrase creates a mood that seems dominant when one takes an over-all look at the college scene. But close inspection partially shatters the mood. Youth, being a state of health, could hardly present a wholly depressing picture, and when barriers and checks are removed even the most apathetic youngster can run overnight into a galvanic creature. At the moment the undergraduate is not capitalizing his hopes; the average student will consider himself lucky if he is getting $3,600 a year five years out of college. And when hopes are not being capitalized under the elms on soft spring nights, it is a sign that the American world has turned over on its axis.

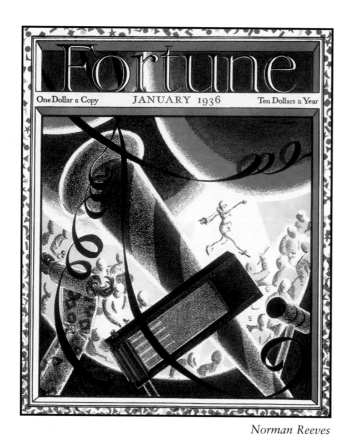

Norman Reeves

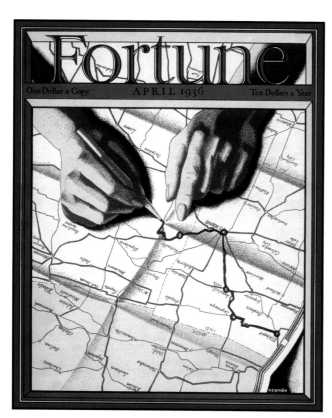

A. J. Grodin

John A. Cook

Antonio Petruccelli

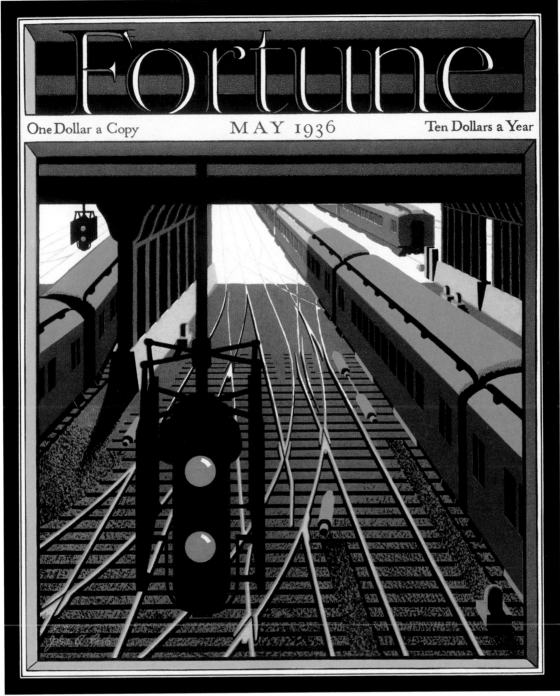

FROM MAY 1936: *Pennsylvania Railroad*

Do not think of the Pennsylvania Railroad as a business enterprise. Think of it as a nation. It is a bigger nation than Turkey or Uruguay. Its boundaries are wider and it has larger revenues and a larger public debt than they. Corporately also it behaves like a nation; it blankets the lives of its 100,000 citizens like a nation, it requires an allegiance as single as a patriot's. The Pennsylvania man who, trained to the railroad, forsakes it, is as abnormal as the U.S. citizen who expatriates himself.

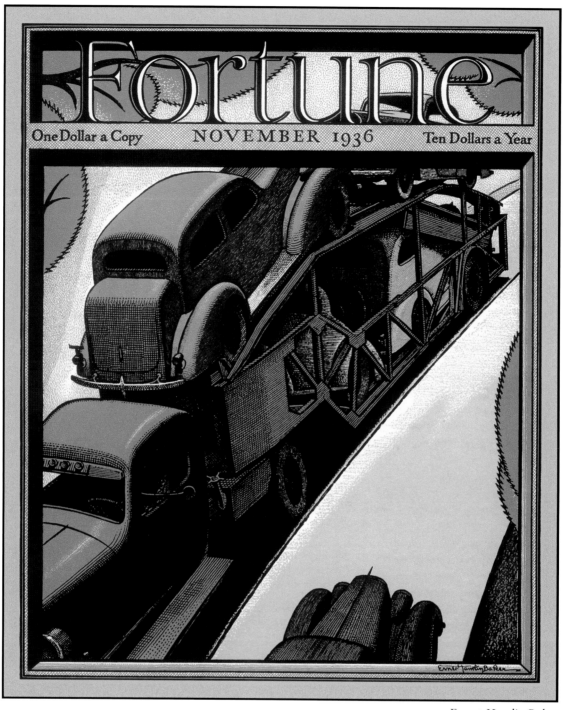

Ernest Hamlin Baker

FROM NOVEMBER 1936: *A Portfolio of New Deal Reconstruction*

In 1936 you can say that the job of reconstruction has pretty well cleaned up the surface of the U.S. and here and there carved, plugged, and tied that surface together until men could use it. . . . And you can say that the New Deal has failed to do what it started out to do by priming the business pump. . . . But the one thing you cannot say is that the New Deal has failed to give the U.S. the biggest house cleaning it has ever had.

56

A. J. Grodin

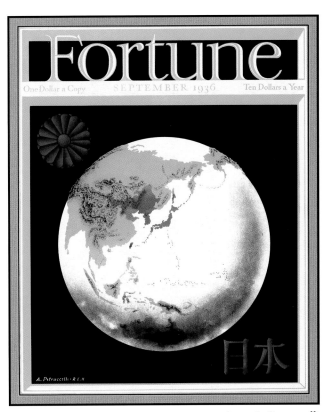

Antonio Petruccelli

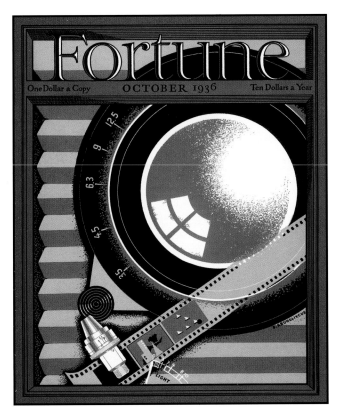

Ernest Krunglivcus

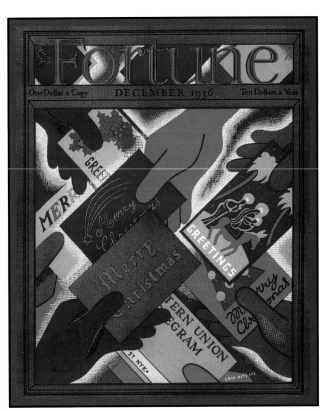

Erik Nitsche

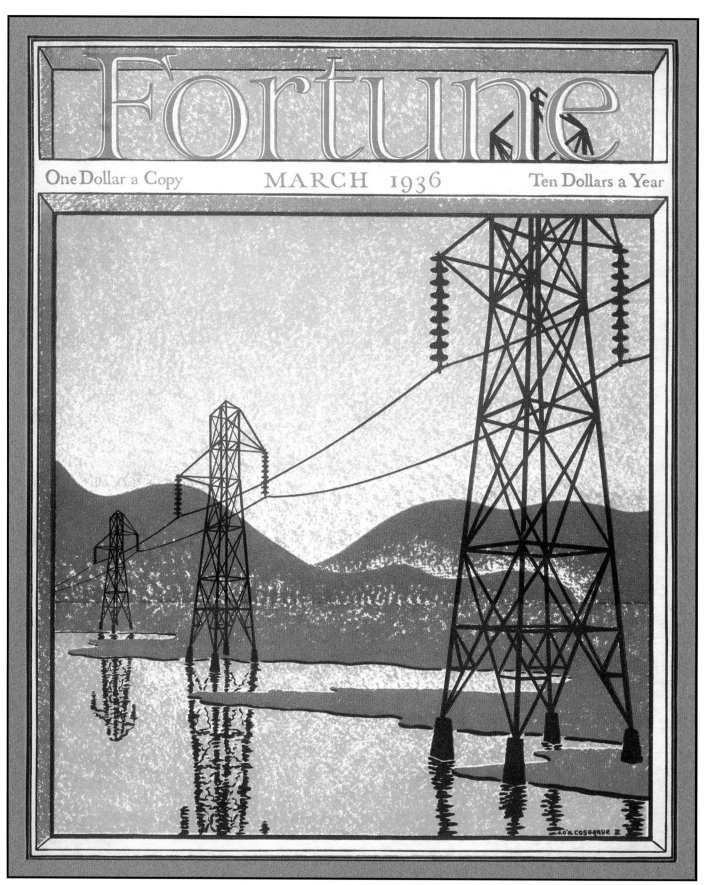

One Dollar a Copy MARCH 1936 Ten Dollars a Year

John O'Hara Cosgrave II

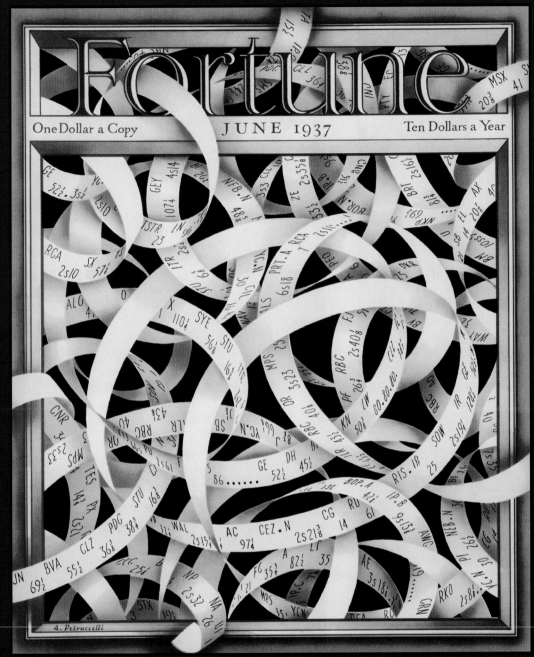

1937

• Golden Gate Bridge opens
• Spam is introduced and soon becomes the world's best-selling canned meat
• American boxer Joe Louis wins world heavyweight title

U.S. GNP
Billions

$90.4

U.S. INCOME
Per Capita

$575.00

UNEMPLOYMENT
Yearly Average

14.3%

Antonio Petruccelli

FROM JUNE 1937: *Wall Street, Itself*

Roughly speaking, if you want to know how high up a man is in Wall Street, find out how high up he eats lunch. So long as he habitually uses the restaurants at street level, he will hardly be more than just promising. . . . When you find him in the Savarin or at Whyte's he's outgrowing the street level—he's about ready for a lunch club, and for the upper stories of skyscrapers, where many of Wall Street's finest lunch clubs are.

Rough averages taken from all the clubs would set yearly dues at $125, daily lunch at $1.25, club membership at 500, members' age at forty-five, and the food at no better than adequate.

A. M. Cassandre

Ernest Hamlin Baker

Antonio Petruccelli

Joseph Binder

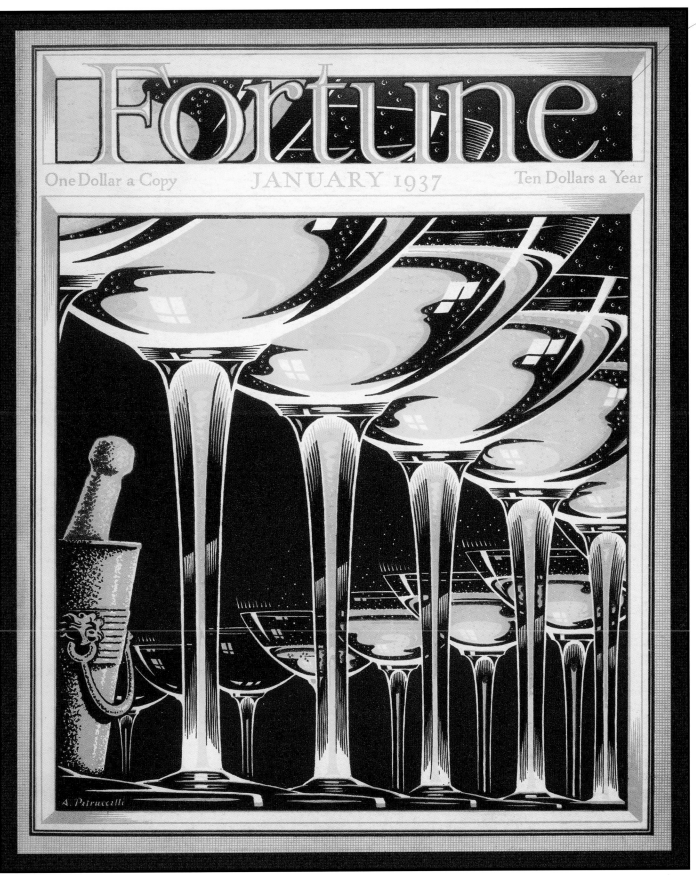

One Dollar a Copy

JANUARY 1937

Ten Dollars a Year

Antonio Petruccelli

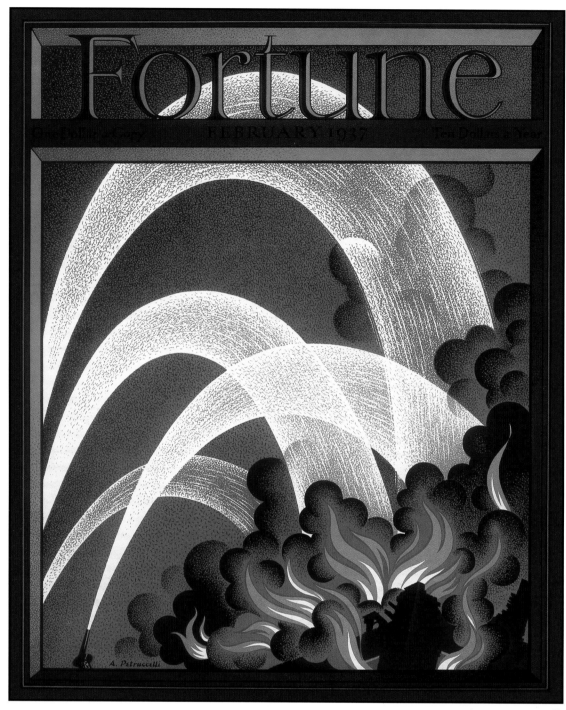

Antonio Petruccelli

FROM FEBRUARY 1937: *On the Beach: New York Waterfront*

The most extraordinary thing about New York Harbor is its size. . . .

New York Harbor has more car floats, lighters, ferries, tugs, canalboats, oil barges, coal barges, steamers, motorboats, floating derricks, floating elevators, scows, and dredges than any harbor in the world. It has some fifty floating docks, six graving docks, forty-seven ship and boat repair yards, and in spite of the fact that the U.S. owns no superliners, it can dry-dock all but twelve of the world's ships.

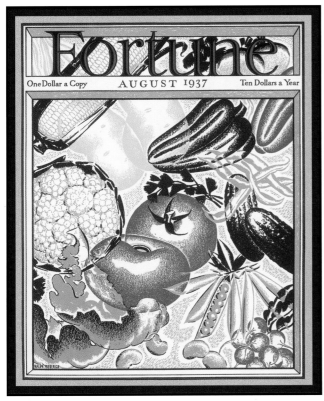

Ralph Frederick

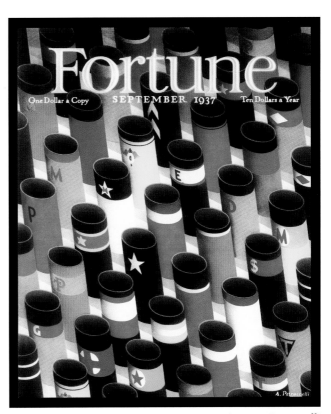

Antonio Petruccelli

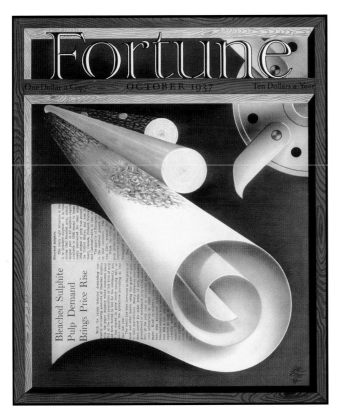

Paolo Garretto

Maurice Freed

Joseph Binder

FROM DECEMBER 1937: *U.S. Taxes*

"Tax" is an ugly word, a confusing word, and a misleading word. For a tax is a great deal more than a "charge," a "burden," or a "contribution," as Mr. Webster would have it. To think of it so is to look through the wrong end of the telescope at the minutiae of taxes, at the "burdens" and petty nuisances that taxes mean to the individual. Taken in the broad view, taxes include in their impact all of wealth and the entire economic structure of nations. Nor is that all. For taxes are, in a sense, only the gross receipts of a business. That business is the business of government.

1938

- *Congress establishes the House Committee on Un-American Activities*
- *Thornton Wilder's* Our Town *is published*
- *DuPont invents Teflon*

U.S. GNP
Billions

$84.7

U.S. INCOME
Per Capita

$526.00

UNEMPLOYMENT
Yearly Average

19.0%

One Dollar a Copy FEBRUARY 1938 Ten Dollars a Year

Alan Atkins

FROM FEBRUARY 1938: *Theatre-Business*

Broadway is the place where names are made in the space of three hours . . . where the Automats are full of slugs, and everybody calls everybody else "Dear" and slips the knife delicately and swiftly into the back, . . . where the standard greeting is, "My dear, you were wonderful," and the standard reply is, "My dear, I was wonderful," and the saddest words are, "They cut my lines."

It is a combination of poetry and hard cash, and of hysteria, megalomania, and delusions of grandeur; it is a nostalgia, and beggars outside the door in tuxedos, and paper roses. It has, in short, little to do with a certain street that goes by the same name, because in essence it is a state of mind.

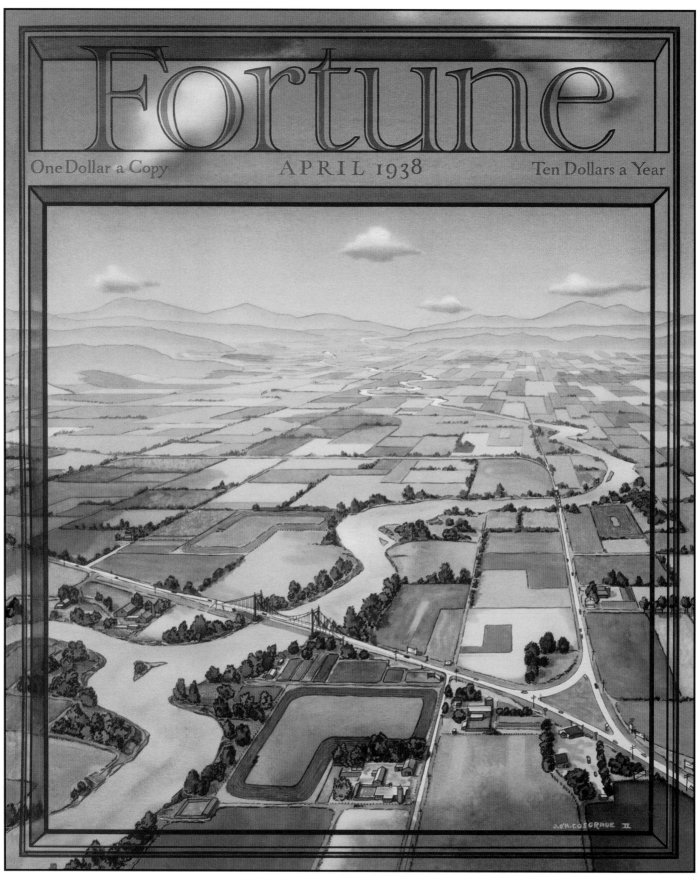

One Dollar a Copy APRIL 1938 Ten Dollars a Year

John O'Hara Cosgrave II

Antonio Petruccelli

S. W. Crane

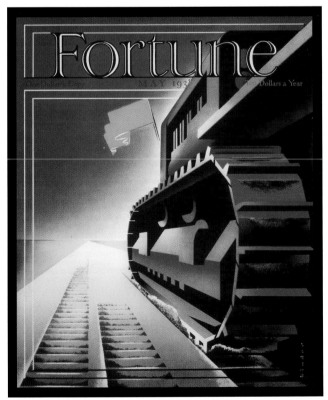

Joseph Binder

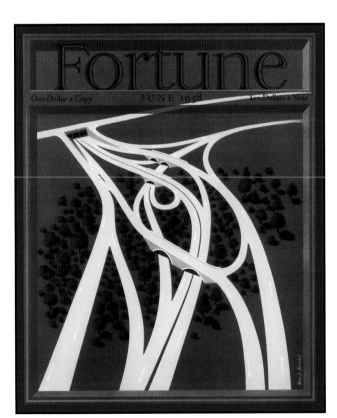

Hans J. Barschel

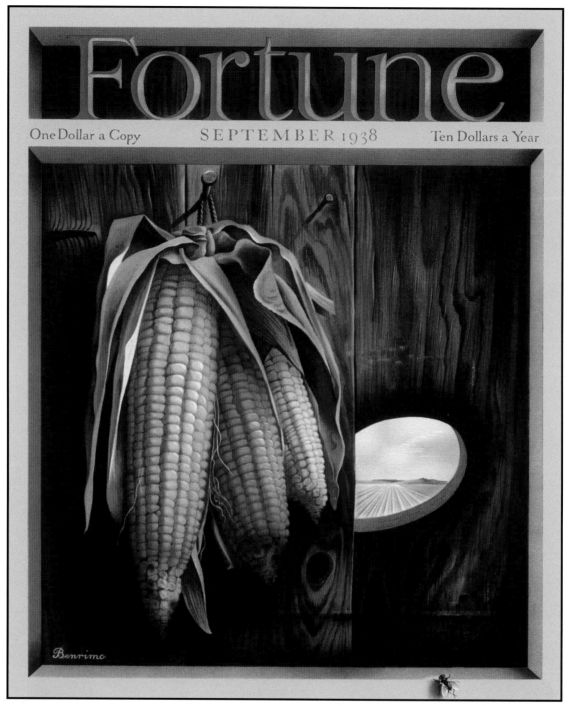

Thomas Benrimo

FROM SEPTEMBER 1938: *Corn Products*

A bushel of shelled corn. Toss it into a feeding trough for little pigs and eventually it is ten pounds of pork on the hoof. Ferment and distill it for five gallons of water-clear, throat-scorching corn liquor. Squeeze it and collect a pound and a half of brown corn oil. Grind it and get forty-three pounds of corn meal. Process it one way for thirty-odd pounds of cornstarch; another way for forty pounds of thick corn sirup; yet a third way for twenty-five pounds of dextrose sugar as white and fine as talc. Gather up the leavings for a couple of pounds of oil cake and a dozen of gluten feed and you have about exhausted the possibilities of a single bushel of shelled corn.

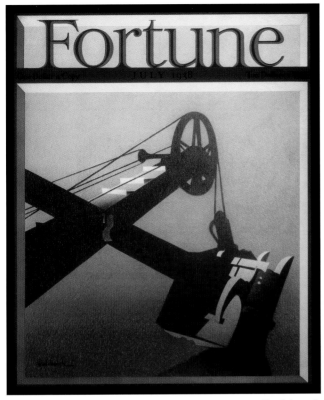

Radebaugh

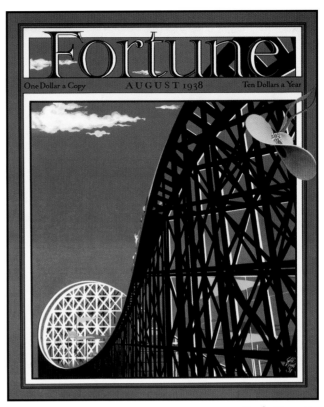

Paolo Garretto

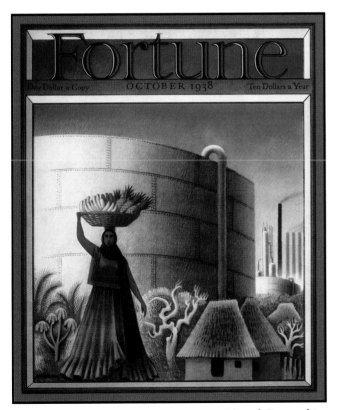

Miguel Covarrubias

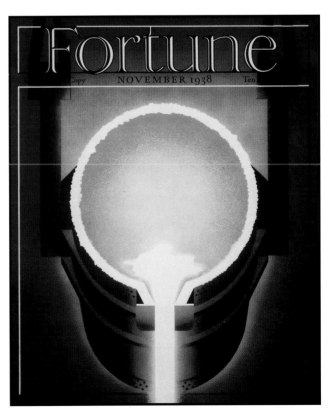

Joseph Binder

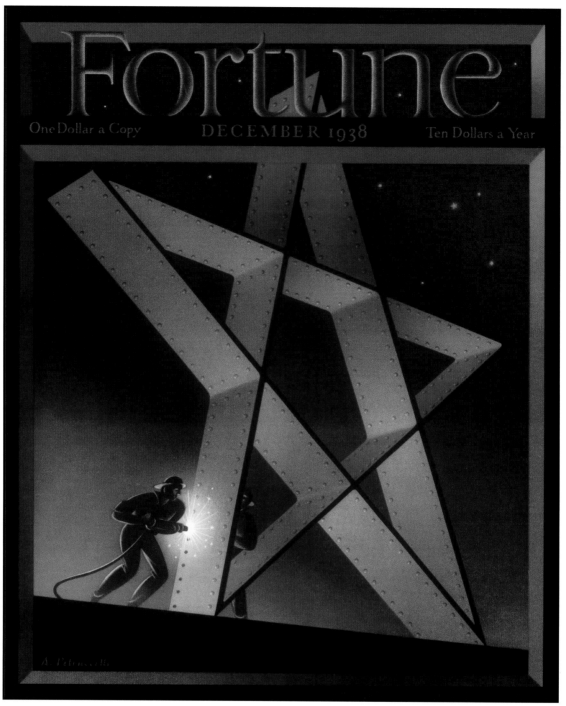

Antonio Petruccelli

FROM DECEMBER 1938: *The U.S. Debutante*

Traditionally [the debut's] ostensible purpose was the perpetuation of a caste type. But its real reason was a husband hunt. The debutante could look over the field of available husbands, and the field could look over her. "Pudding, Alice. Alice, Pudding." And the debut was not only into society, but into marriage.

From the society into which a New York girl makes her debut today adults, and especially men—marriageable or otherwise—have almost completely disappeared. . . . The social game costs time and money. It flourishes where there is most leisure for caste and least pressure for cash.

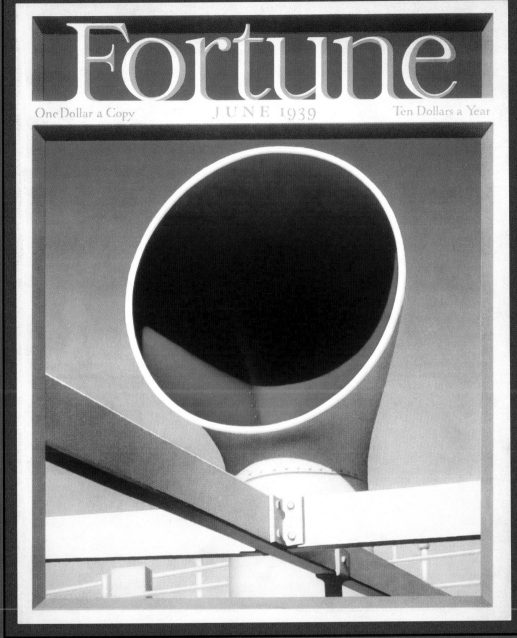

1939

• Germany invades Poland, beginning World War II
• Pan American Airways starts regular trans-Atlantic and trans-Pacific service
• The first televised baseball game enthralls America

U.S. GNP
Billions

$90.5

U.S. INCOME
Per Capita

$555.00

UNEMPLOYMENT
Yearly Average

17.2%

Francis Brennan

FROM JUNE 1939: *Business-and-Government*

In our own land there is profound bewilderment. There is bewilderment concerning capital, which lies idle. There is bewilderment concerning industry, which, in the face of an enormous potential demand, does not produce. There is bewilderment in the face of labor. And most of all, there is bewilderment concerning government—what it is here for and what it is supposed to do.

Yet a philosopher willing to peer behind these conflicts of opinion and practice might bring forth some simple and helpful truths. And perhaps the simplest of all would be this: that there are 2,000,000,000 people on the earth seeking to enjoy life; that all economic enterprises exist inasmuch as they establish, or produce, or cause or expand enjoyment; and that the function of government is to enable enjoyment to be had, and in a sense to guarantee it.

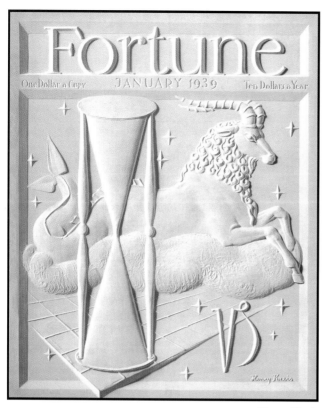

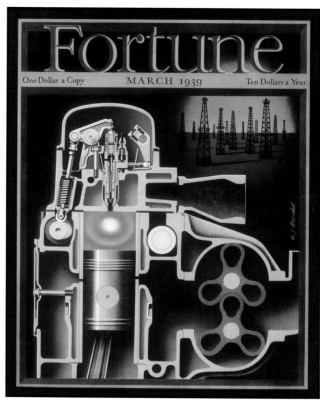

Henry Kreis

Hans J. Barschel

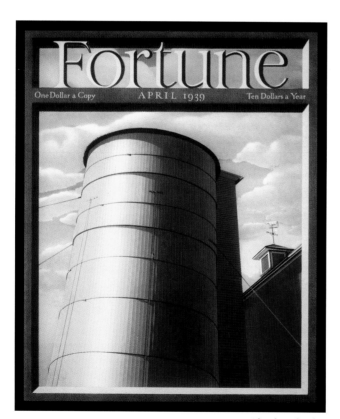

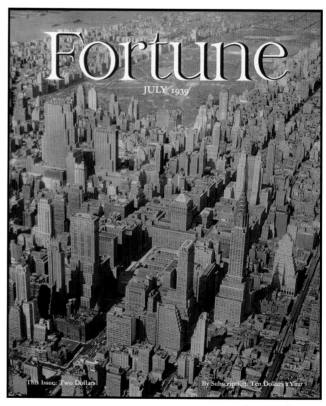

Charles Sheeler

Artist unknown

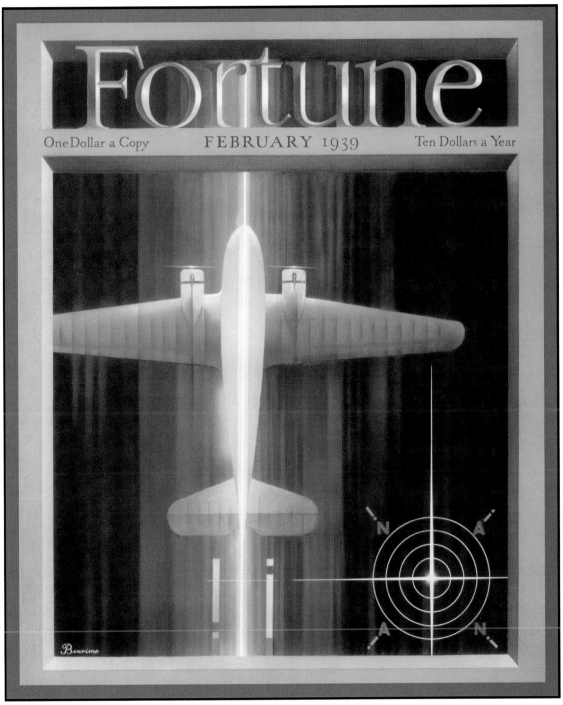

One Dollar a Copy FEBRUARY 1939 Ten Dollars a Year

Thomas Benrimo

FROM FEBRUARY 1939: *Homemade Survey*

It may not have occurred to you that your own phone book can give you a homespun idea of the New Deal's popularity. The 1933 summer issue of the *Manhattan Telephone Directory*, for example, listed fifteen enterprises christened "New Deal," and by the next winter there were thirty-five, including the "New Deal Fish Co." and the "New Deal Live Poultry Corp." One year later there were forty-four, among them the "New Deal Corset & Brassiere Co.," the "New Deal Dumbwaiter Co.," and the "New Deal Egg Corp." Summer, 1936, listed only thirty-four, but from there on the New Deal fluctuated within a narrow range around thirty-seven and moved up to forty-four this winter.

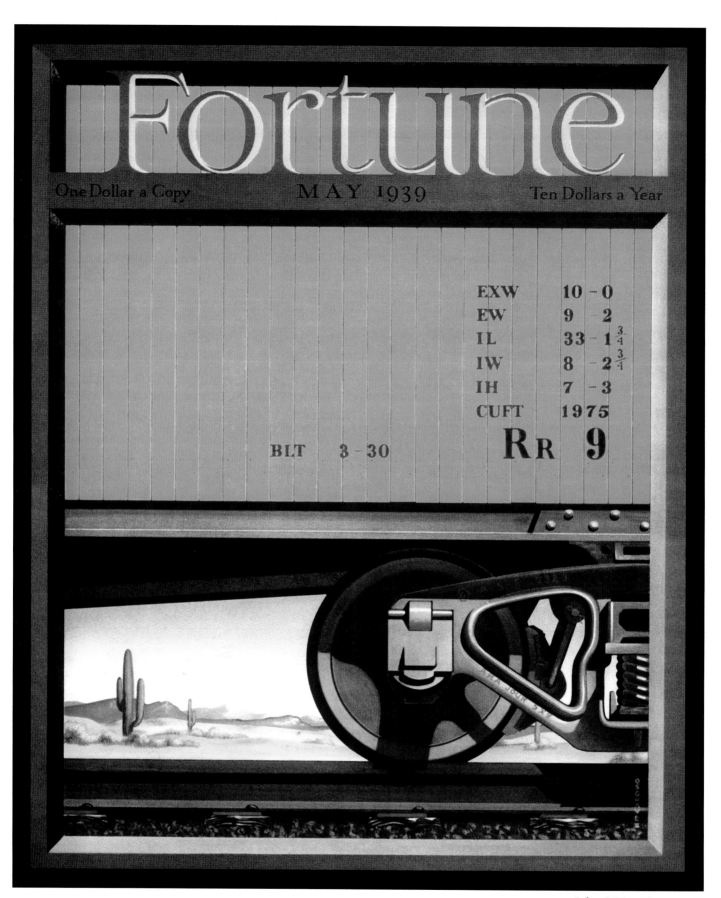

John O'Hara Cosgrave II

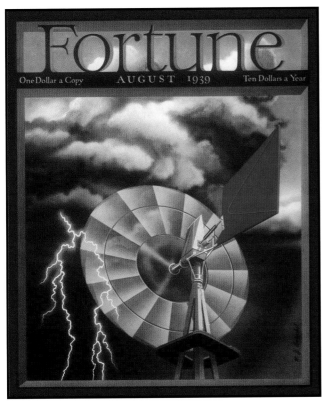

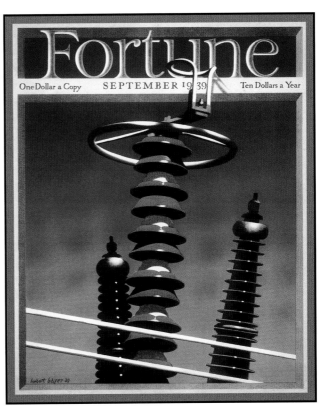

Hans J. Barschel

Herbert Bayer

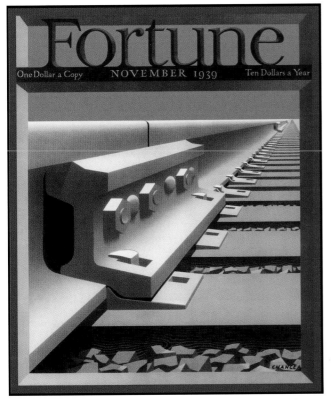

Fred Chance

Arthur Gerlach

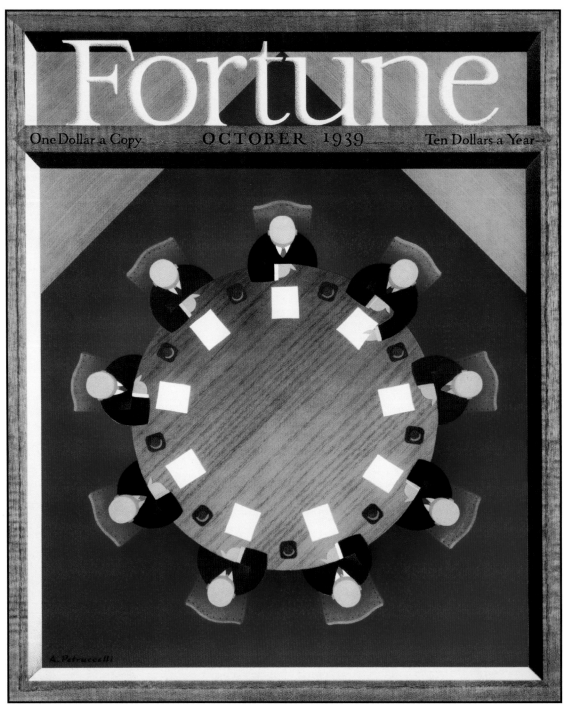

Antonio Petruccelli

FROM OCTOBER 1939: *The War of 1939*

During the night of Thursday, August 31, while FORTUNE's October issue was being sent to the printer for final closing, Hitler marched into Poland. All night long the teletype rattled out the unbelievable news. Little groups of writers and researchers stood reading the long streamers of tape, returning to their desks to finish up their jobs as best they could. The editors could do nothing about the news. Their issue . . . could not be turned in the space of a few hours to meet the emergency of war. So in the dawn the staff finished "October." And they walked out among the gray, deserted buildings of the city with the feeling that they had closed, not an issue of a magazine, but an era in human affairs.

1940

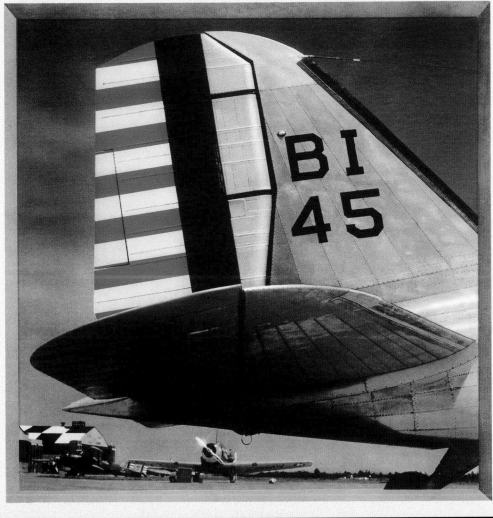

Fortune

One Dollar a Copy SEPTEMBER 1940 Ten Dollars a Year

BI 45

Otto Hagel

- *Winston Churchill becomes prime minister of Great Britain*
- The Shadow *and* The Jack Benny Show *are popular radio programs*
- *Hemingway's* For Whom the Bell Tolls *is published*

U.S. GNP
Billions

$99.7

U.S. INCOME
Per Capita

$593.00

UNEMPLOYMENT
Yearly Average

14.6%

FROM SEPTEMBER 1940: *U.S. Defense: The Armed Forces*

If the [German] menace was real, and the fear as healthy as a cowhand's fear of a rattler, the drive to meet it remained unchanneled, without real focus. The reason was obvious: "defense," as a concept, springs from a negative psychology, and the country that arms under the shibboleth of "defense" is in the position of a boxer trying to cover up in the region of his solar plexus, his chest, his jaw, and his temples all at the same time. What was needed [in Europe] to fuse the energy aroused by the fear was an objective, a positive emotion, a marching song, and a plan not so much for hemisphere "defense" as for a hemisphere way of life—a part patriotic, part religious democratic faith that would result in the correct strategical moves almost as byproducts.

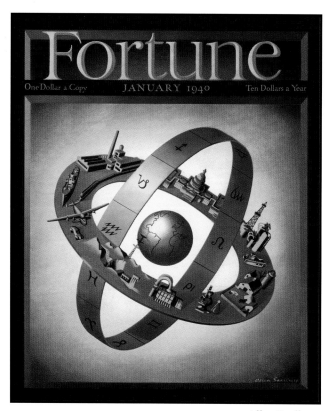

Allen Saalburg

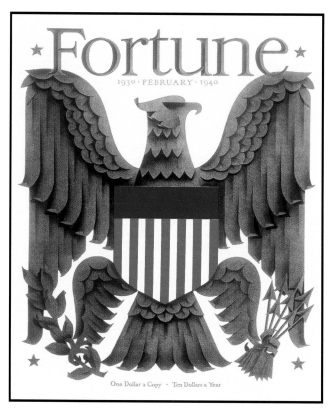

Antonio Petruccelli

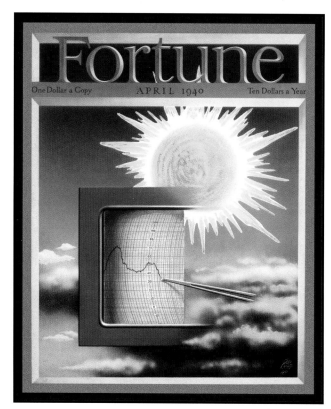

Paolo Garretto

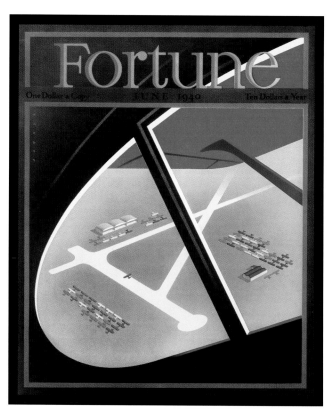

Joseph Binder

78

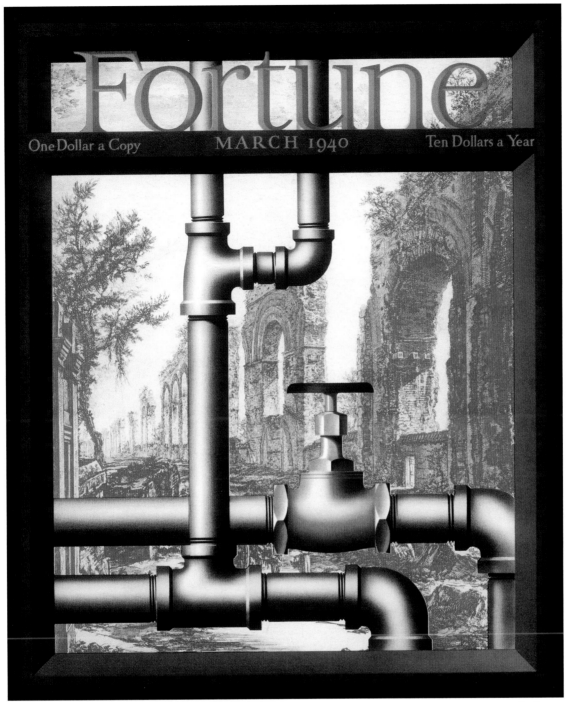

Fortune

One Dollar a Copy MARCH 1940 Ten Dollars a Year

Fred Chance

FROM MARCH 1940: *Master Plumber*

Calvin is [a] journeyman plumber.

He's sore when he gets inside the Thompson house and sees Mrs. Thompson look at the clock. So she's going to keep a stop watch on him. Lots of women do that, and it annoys plumbers, sometimes makes them drag out the work just to get even. A woman watched the clock on Fred Flader once and complained, when he finished, that his bill was too high. He explained that the "service charge" was for labor from the time of leaving the shop till the return to the shop. She argued; Flader argued. The argument lasted half an hour. "And now, madam, it'll be $1.12 more for the time you've been talking." She paid it.

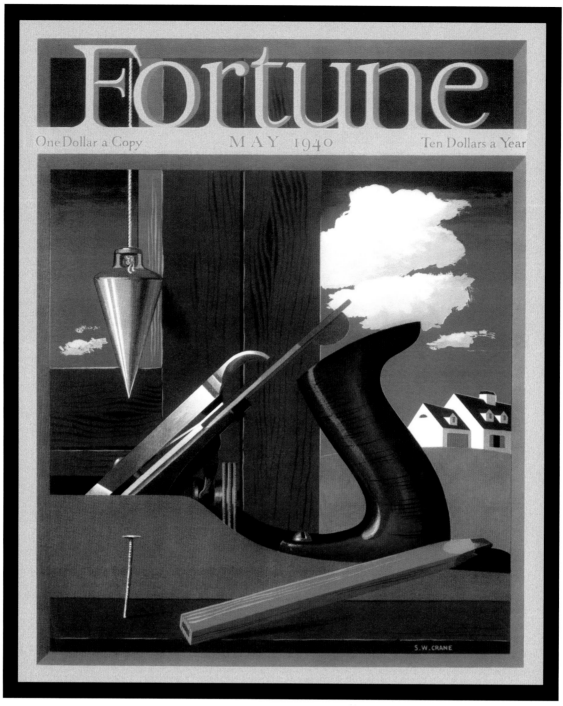

S. W. Crane

FROM MAY 1940: *The Fortune Survey: Eleanor Roosevelt's Career*

What should Mrs. Roosevelt do if she does not return to the White House next year?

	Men	Women	Total
Be elected or appointed to some high government office	5.8%	7.3%	6.5%
Continue with various activities like writing and lecturing	39.1	49.5	44.3
Retire entirely from the public eye	30.3	17.7	24.1
Other	1.0	1.4	1.2
Don't care what she does	13.9	11.7	12.8
Don't know	9.9	12.4	11.1

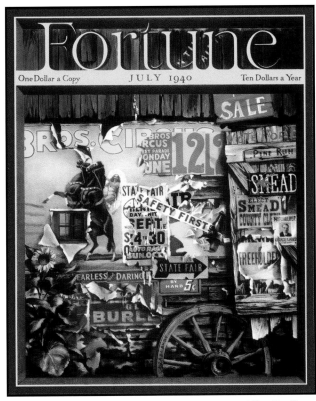

Allen Saalburg

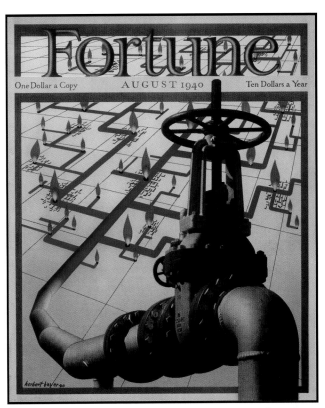

Herbert Bayer

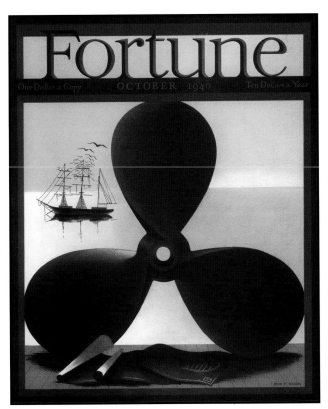

John F. Wilson

Antonio Petruccelli

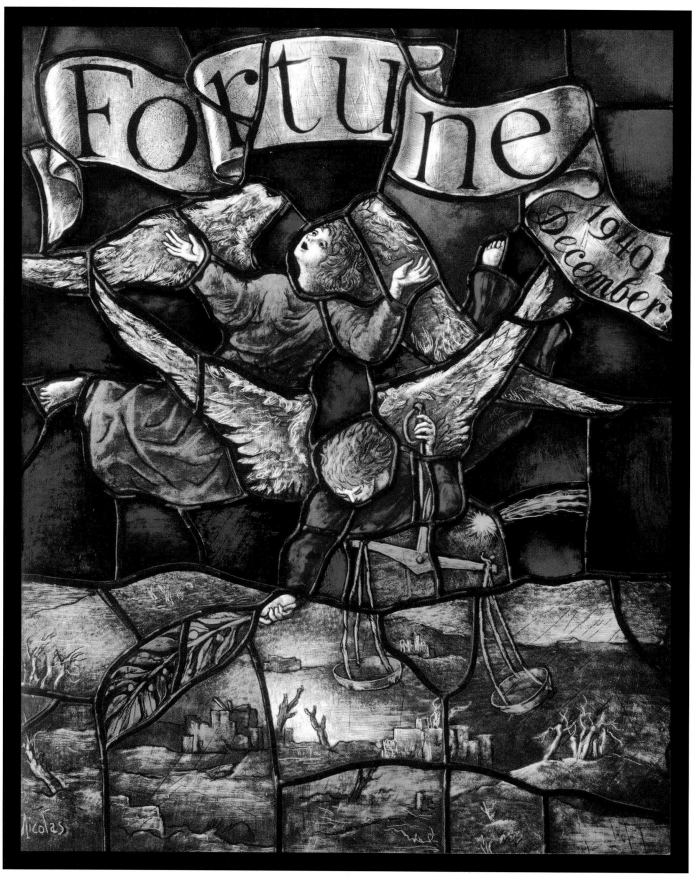

Joep Nicolas

1941

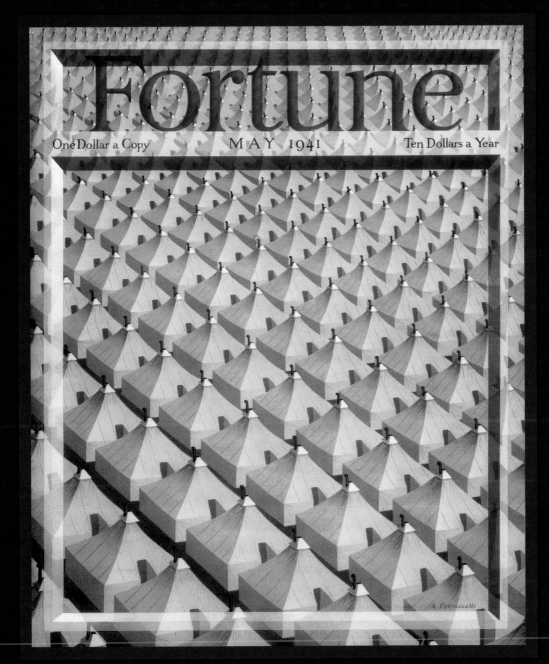

U.S. GNP
Billions

$124.5

U.S. INCOME
Per Capita

$719.00

UNEMPLOYMENT
Yearly Average

9.9%

Antonio Petruccelli

FROM MAY 1941: *The Future of U.S. Foreign Policy*

For the second time in a quarter of a century Americans are awakening to the fact that they have become involved in a world war. It is a rude awakening. And it is also a dangerous awakening. It is rude because the isolationists have been telling us for twenty-two years that it is not only desirable but possible to stay out of world war. And it is a dangerous awakening because we are not entirely sure, as a nation, why we have become involved. We have not yet answered to our satisfaction the question, "What for?"

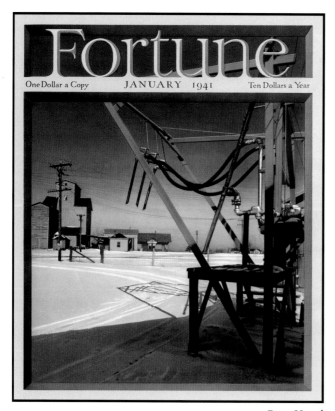

Otto Hagel

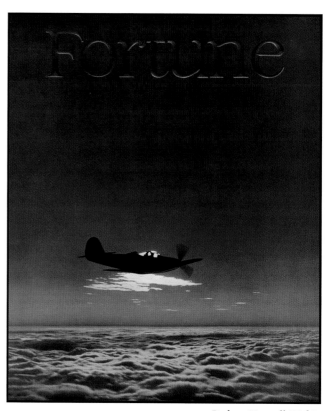

Robert Yarnall Richie

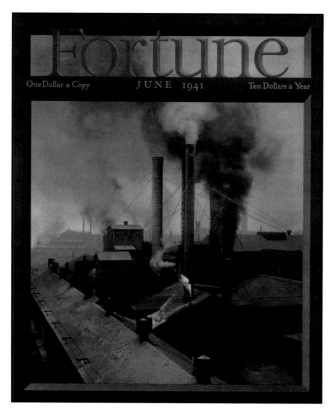

Dmitri Kessel

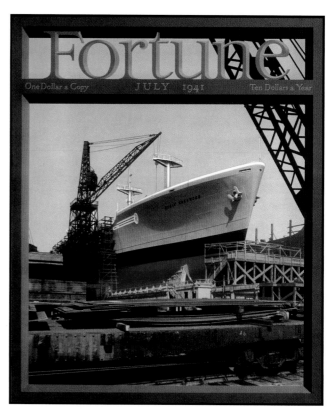

Robert Yarnall Richie

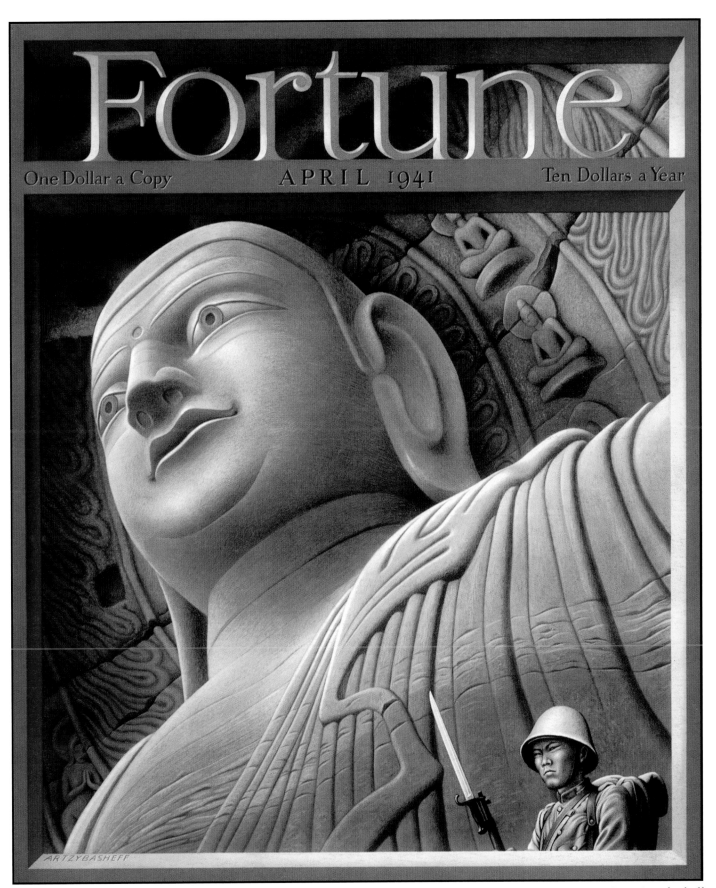

Boris Artzybasheff

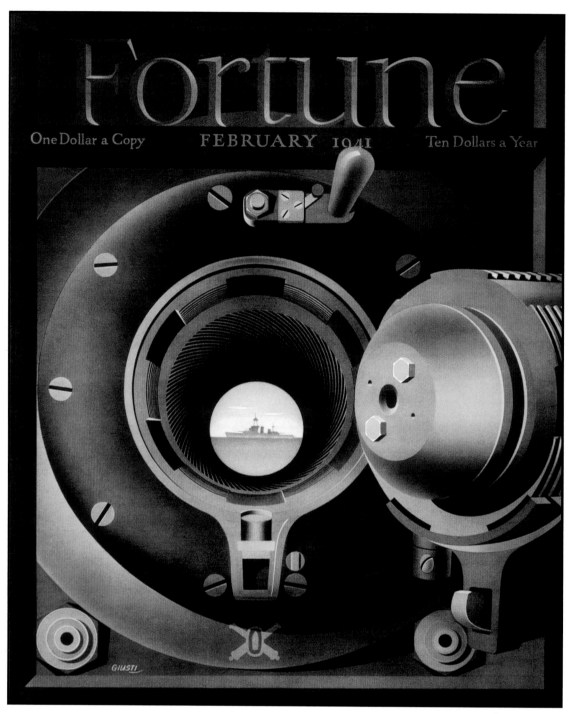

One Dollar a Copy FEBRUARY 1941 Ten Dollars a Year

George Giusti

FROM FEBRUARY 1941: *The U.S. and the World*

The U.S. must be strong not next year, not in 1945, but at least morally, *tomorrow*. Miracles are in order. In span a month is a long time now. The combined Dutch, Belgian, French, and British armies were smashed in a little over a month. Sovereign states have gone under in days. . . . Given time, the U.S. can amass the greatest pile of armaments the world ever saw. Given time it can train the men to man them. But time is what the enemy does not give—and the enemy is on both flanks. Not only must the U.S. do a better job, if it is to survive even as an equal: it must do a better job faster.

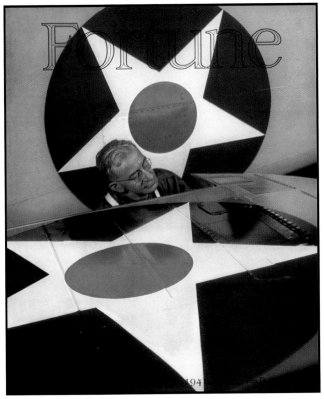

Dmitri Kessel

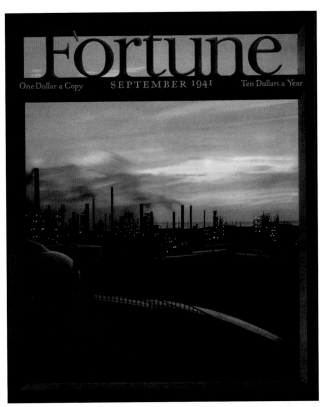

Robert Yarnall Richie

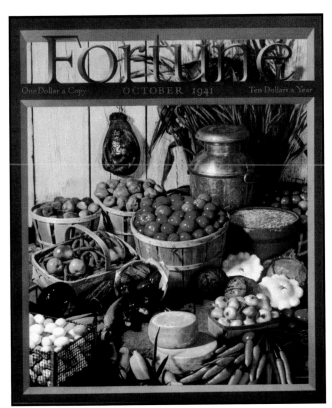

Arthur Gerlach

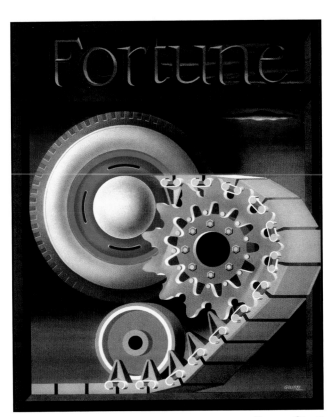

George Giusti

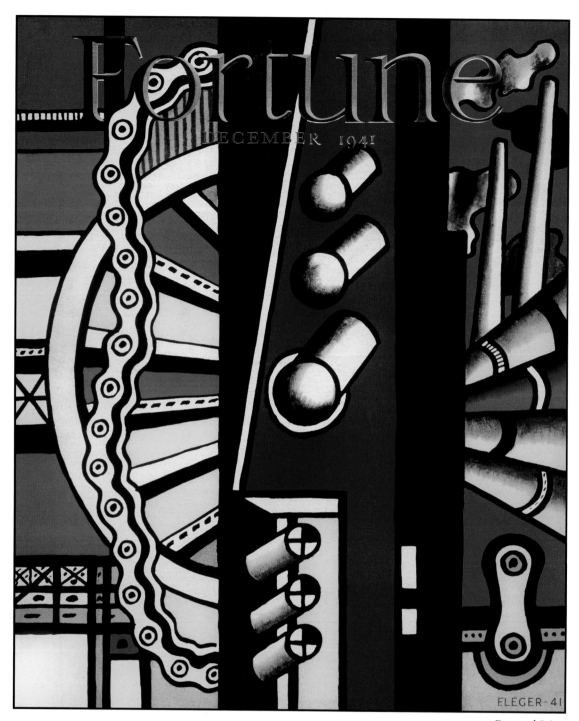

Fernand Léger

FROM DECEMBER 1941: *The Great Flight of Culture*

The migration coming to the U.S. today is perhaps the most extraordinary of the many that have served to people this continent. For this is not just people fleeing famine or oppression. This is a transplantation of a whole culture from one continent to another. Since the rise of Hitler, a large body of Europe's intellectual leadership has been moving to the U.S. . . . But there is no ready pot in which to melt and fuse the dynamic forces of art and of ideas. The great questions are whether, during American trusteeship, Europe's transplanted culture will flourish here with a vigor of its own, or languish for lack of acceptance, or hybridize with American culture, or simply perish from the earth.

1942

• Voice of America *broadcasts begin in Nazi-held Europe*
• *Polio epidemic strikes the U.S.*
• *Humphrey Bogart and Ingrid Bergman star in the classic film* Casablanca

U.S. GNP
Billions

$157.9

U.S. INCOME
Per Capita

$911.00

UNEMPLOYMENT
Yearly Average

4.7%

John Atherton

FROM DECEMBER 1942: *The Main Street Front*

The 17,000 inhabitants of Mattoon, Illinois, do know there's a war going on. They've seen 800 of their young men go into the Army or Navy . . . they've met their war-bond quota; they've left peacetime jobs and started working on wartime jobs. They've seen prices go up, and wages, too. Their unemployed have found jobs, and along with increased employment, union organizers have come to town. Women and girls have quit housework and stenography and gone to work in factories, and as bartenders and filling-station operators. . . . But Mattoon is not to be considered typical of every town in America, because economic conditions and geography affect men's lives and thoughts even more in war than in peace, and no town is typical. No town is average.

Fortune

ONE DOLLAR A COPY MAY 1942 TEN DOLLARS A YEAR

THE WAR OF SHIPS

Hans J. Barschel

Fenno Jacobs

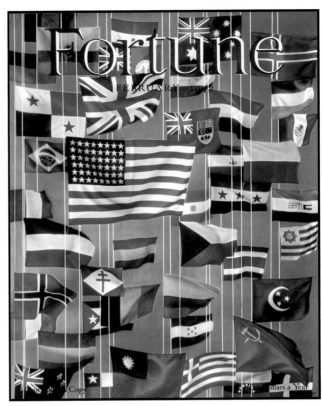

Herbert Matter

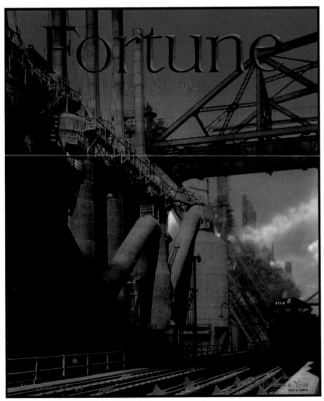

Fred G. Korth

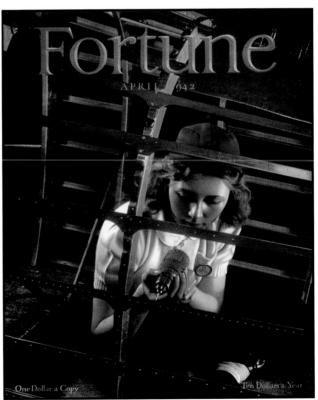

Artist unknown

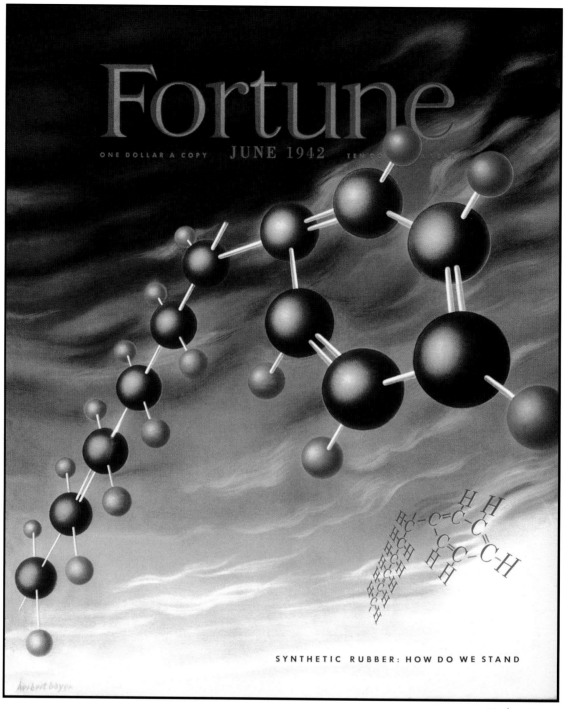

SYNTHETIC RUBBER: HOW DO WE STAND

Herbert Bayer

FROM JUNE 1942: *The Negro's War*

The American Negro . . . is not disturbed by the principles of American government but by the fact that these principles are not fully applied to him. Three months before the U.S. was attacked, *The Crisis,* a Negro journal, stated: "We shall see what we shall see. Negro Americans might as well discover at the beginning whether they are to fight and die for democracy for the Lithuanians, the Greeks and the Brazilians, or whether they had better fight and die for a little democracy for themselves." . . . The American Negro is agitated not because he is asked to fight for America but because full participation in the fight is denied him. He is humiliated as a Negro because he is not fully accepted as an American.

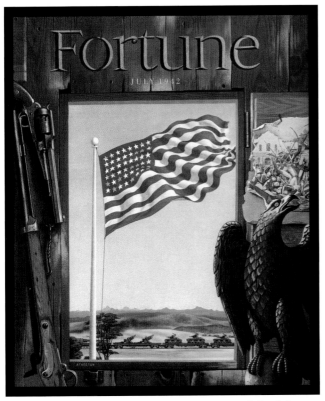

John Atherton

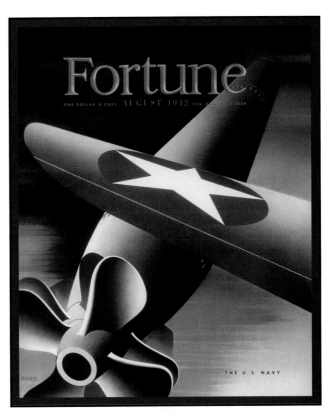

George Giusti

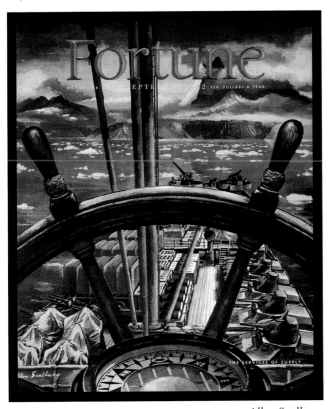

Allen Saalburg

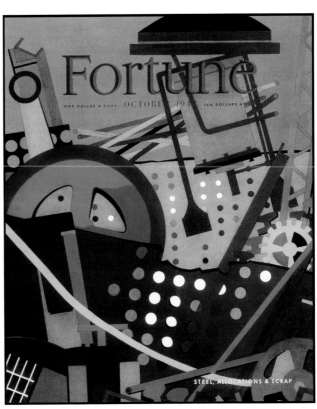

Artist unknown

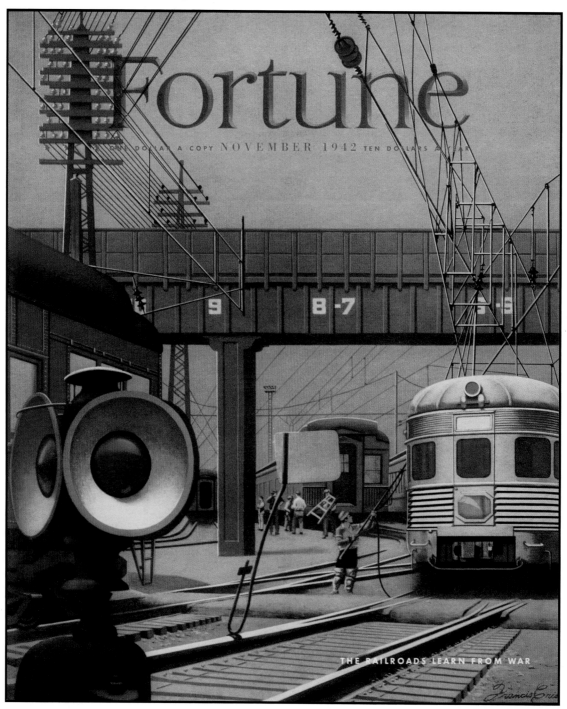

Francis Criss

FROM NOVEMBER 1942: *How the Railroads Did It*

Probably no U.S. industry has ever astonished its partisans and critics—and itself—more than the railroad industry. A year and a half ago many an authority anticipated a breakdown and spoke of the industry's future as a private enterprise in the way an undertaker might speak of an octogenarian with cancer of the liver. So far, however, the railroads have met every [war time] demand that people thought they could not meet. . . . As the result of such performances, they have afforded the government neither a reason nor an excuse to take them over as a war measure.

94

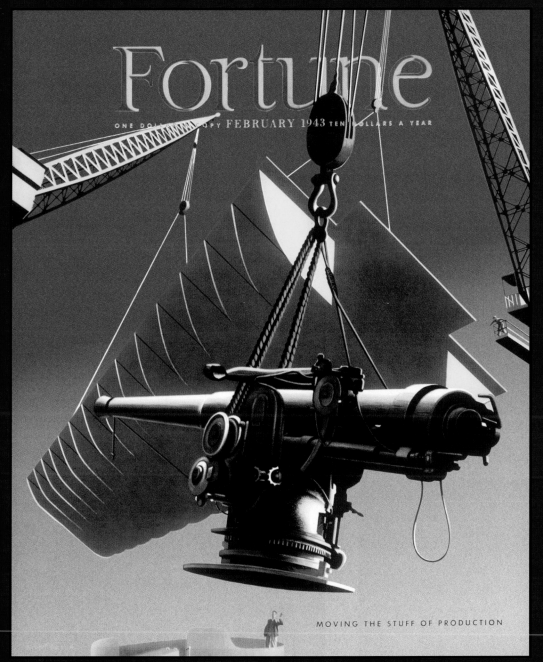

MOVING THE STUFF OF PRODUCTION

Herbert Bayer

• *Eisenhower is named Supreme Commander of the Allied Forces*
• *Zoot suits and jitterbugging are the rage*
• *The musical* Oklahoma! *opens on Broadway*

U.S. GNP
Billions

$191.6

U.S. INCOME
Per Capita

$1106.00

UNEMPLOYMENT
Yearly Average

1.9%

FROM FEBRUARY 1943: *The Margin Now Is Womanpower*

Forecasts show that about four million people who have never worked before must be enlisted in the labor force. They will have to be mostly women because nearly all the men are already working or fighting.

Women are working as barbers, butchers, taxi drivers, slaughterhouse workers, railroad track tenders, fire fighters in the forests, whistle punks in the logging camps. . . . Shipyards are using women not only in shop assemblies, but even as keel welders outdoors.

The number of women already at work and the variety of jobs open to them show that industry has already done a first-class job of recruitment, training, and personnel direction. But it must do more.

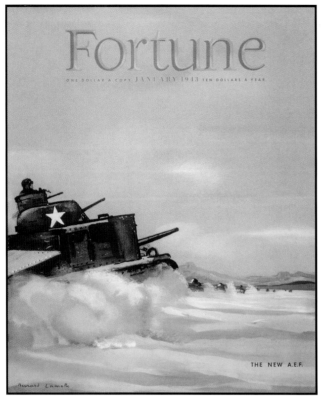

Bernard Lamotte

Artist unknown

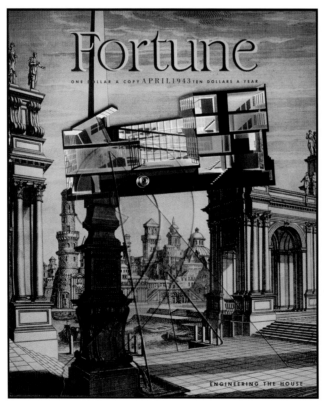

Fortune Art Department

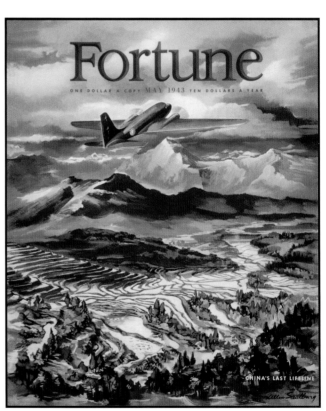

Allen Saalburg

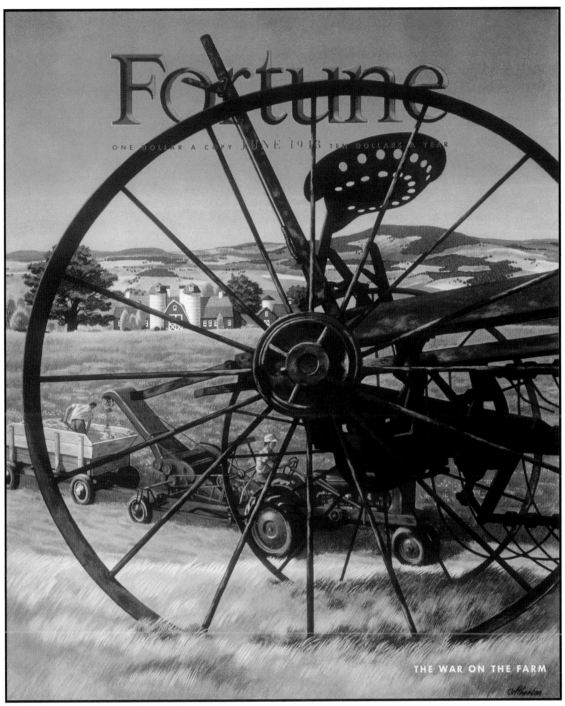

John Atherton

FROM JUNE 1943: *The Job Before Us*

One of those pat and utterly misleading statistics that has been tossed about for the last two decades is that only about 25 per cent of the U.S. people now live on farms. The implication is that only a quarter of the population looks to agriculture for a living. In reality there is almost another 20 per cent who live in villages and towns of less than 2,500 and whose living derives largely from agriculture. Beyond that is the urban population dependent directly and indirectly, in whole or in part, upon the farm market. The farm is still the broad enduring base upon which the entire U.S. economy rests.

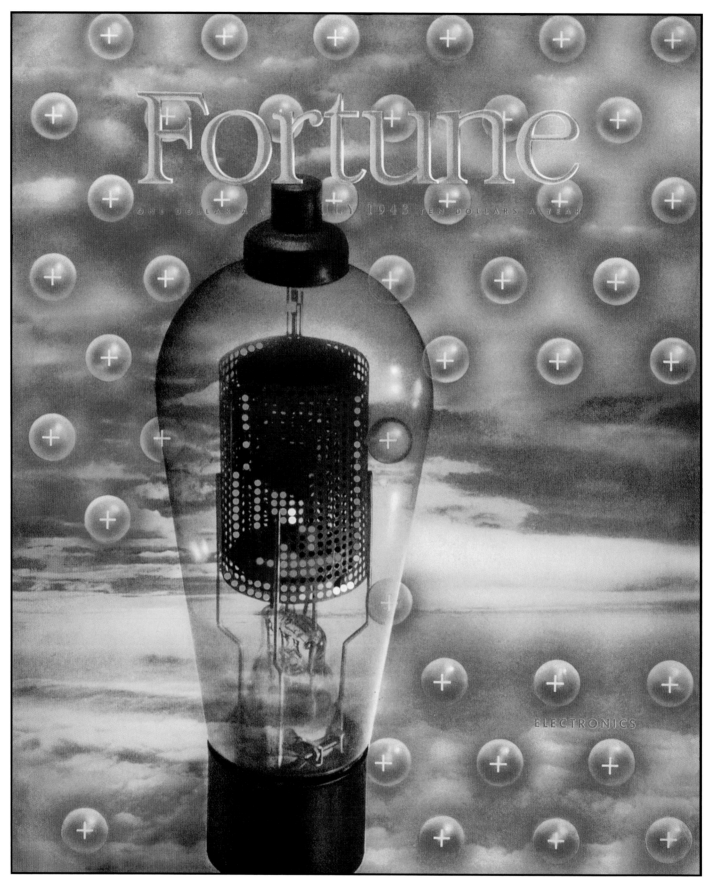

Fortune

ONE DOLLAR A COPY JULY 1943 TEN DOLLARS A YEAR

ELECTRONICS

Artist unknown

Antonio Petruccelli

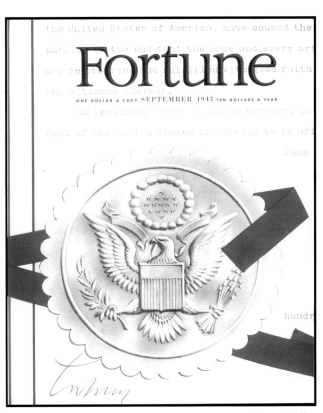

Hans Moller

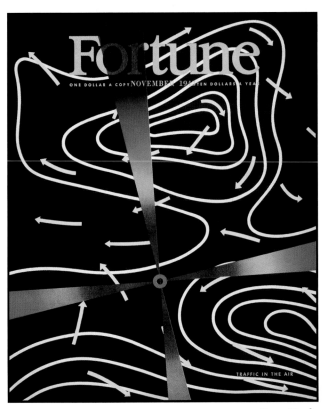

Peter Vardo

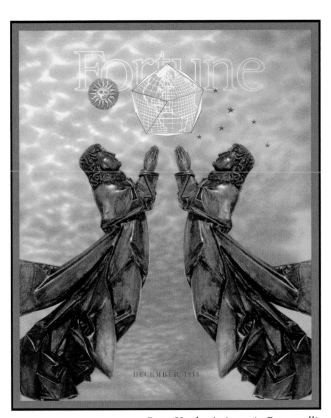

Peter Vardo & Antonio Petruccelli

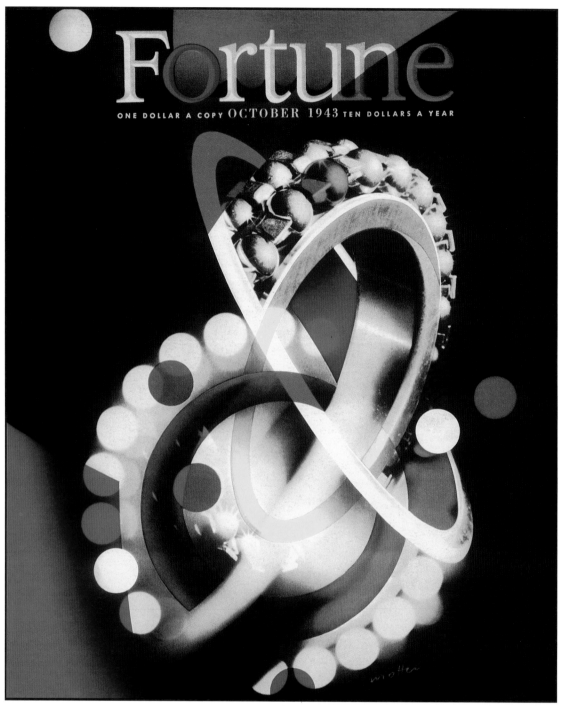

Herbert Matter

FROM OCTOBER 1943: *Quality Control*

In a Flying Fortress traveling around 300 miles an hour at 20,000 feet, the bombardier would miss his target by several hundred yards if any of the six 3/32-of-an-inch balls in the bombsight's tilting-control bearing should vary in smoothness more than 1/1,000,000 of an inch. . . . Already a commonplace, an accepted wonder, this accuracy in large measure depends upon a little publicized technique of management: quality control. Under wartime urgency to meet measurements more exacting than ever before, U.S. industry has been moving quality control away from rule of thumb toward rules rigid as physical law.

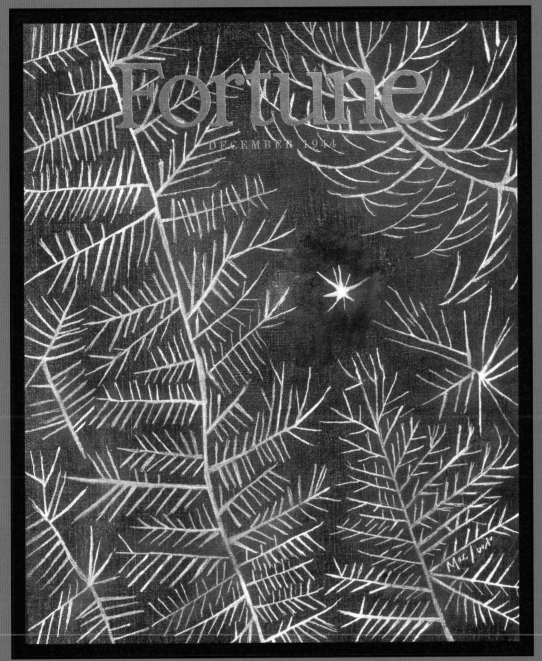

1944

• *President Roosevelt reelected to unprecedented fourth term*
• *GI Bill enacted, providing benefits for WW II veterans*
• *The Adventures of Ozzie and Harriet is popular on radio*

U.S. GNP
Billions

$210.1

U.S. INCOME
Per Capita

$1194.00

UNEMPLOYMENT
Yearly Average

1.2%

Loren MacIver

FROM DECEMBER 1944: *Business Abroad: Retribution*

Through the awful destruction that Germany has caused and is causing comes one note of retributive justice. The "German problem" so hotly discussed in every country has definitely changed shape owing to the carrying of the war to Germany itself. It is becoming more apparent that the great postwar problem will be less how to "control" German industry than to choose what industries may be rebuilt. . . .

War may well do what peace plans could not: reduce Germany's potential to a point where, given a modicum of Allied unity, the economy of the master race can be reshaped to more constructive purposes than after 1918. At least we shall start with a clean slate.

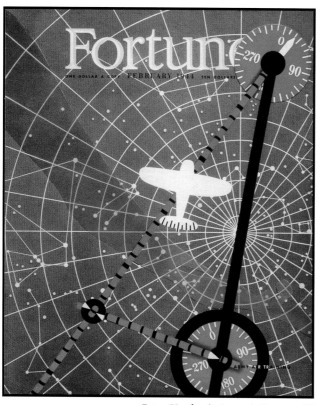

Peter Vardo & Antonio Petruccelli

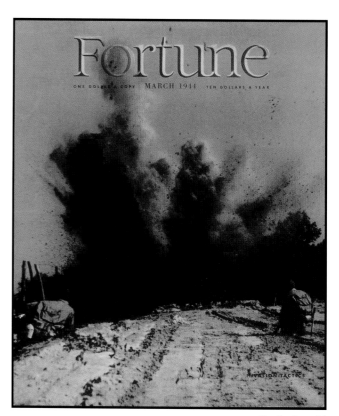

Rudy Arnold

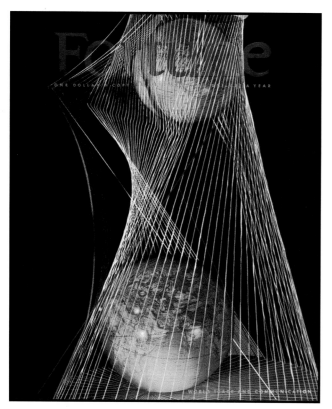

Peter Piening

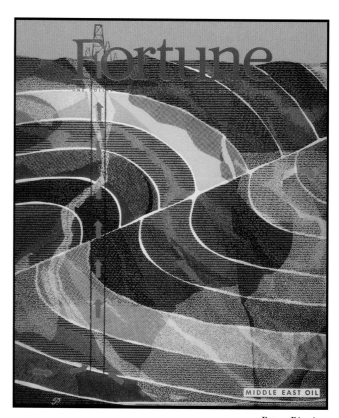

Peter Piening

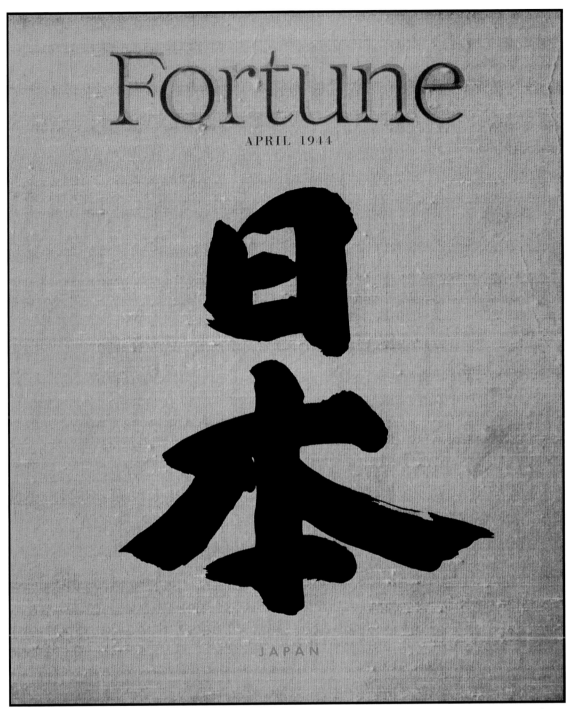

Fortune

APRIL 1944

日本

JAPAN

Taro Yashima

FROM APRIL 1944: *The Job Before Us*

U.S. citizens are no farther from the country of Japan than our soldiers are from the battle howls of Japan's Army. We must reckon with that country for the sake of our individual and national well-beings, and it is doubtful that the account will be closed before the end of a generation, for we have not only to defeat Japan in war but to keep her at peace. For a long time Japan will be at close range.

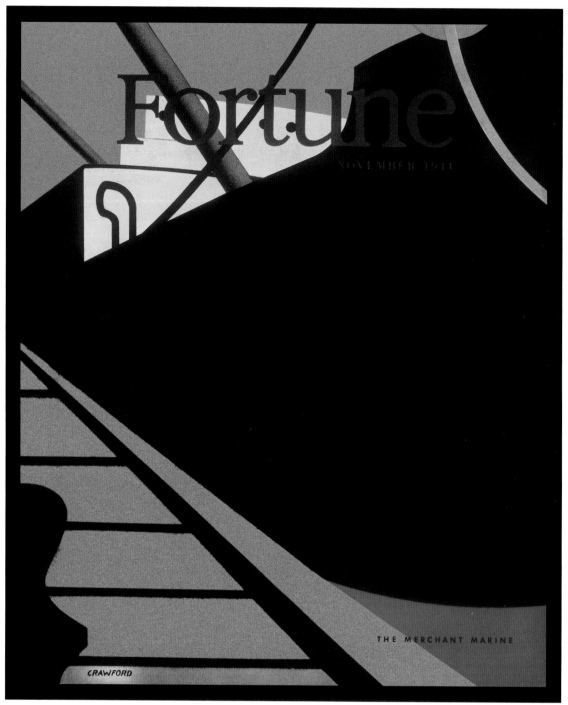

Ralston Crawford

FROM NOVEMBER 1944: *The Working Front: Will Butter Win the Peace?*

During the war [margarine] has picked up enough consumer backing to terrify the butter industry. . . .

The [margarine] industry knows it will not win any of its battles without a knockdown fight. In an earlier round of the battle, *The Dairy Record* gave notice that the butter industry would fight to the death. Said *The Dairy Record* editorially: "We are dealing with an implacable enemy who is never satisfied. . . . The dairy industry must set as its goal the complete extermination of oleomargarine. It must never rest until the manufacture and sale of oleomargarine has been outlawed in this country."

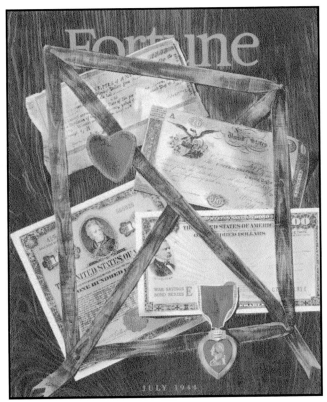

Peter Piening

Peter Piening

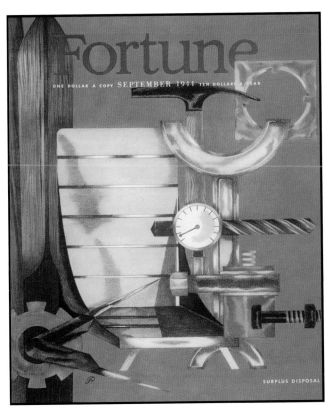

Peter Piening

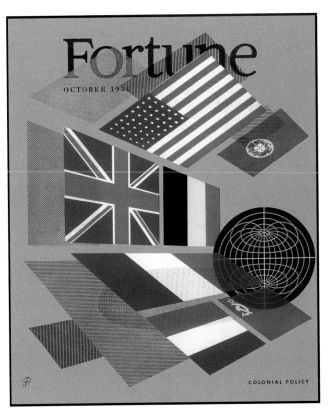

Peter Piening

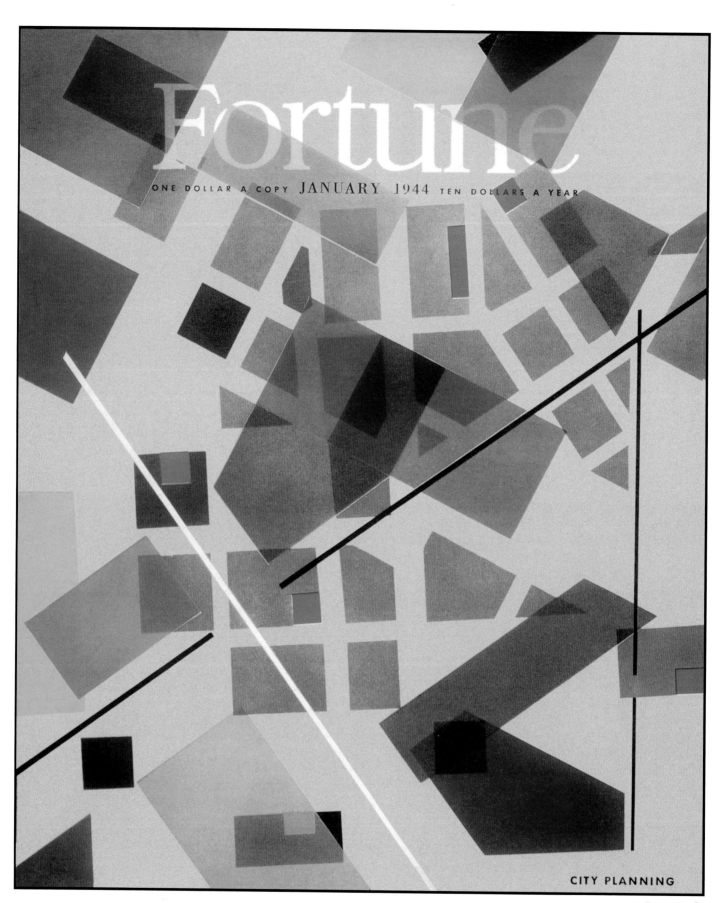

Fortune

ONE DOLLAR A COPY JANUARY 1944 TEN DOLLARS A YEAR

CITY PLANNING

Peter Vardo

1945

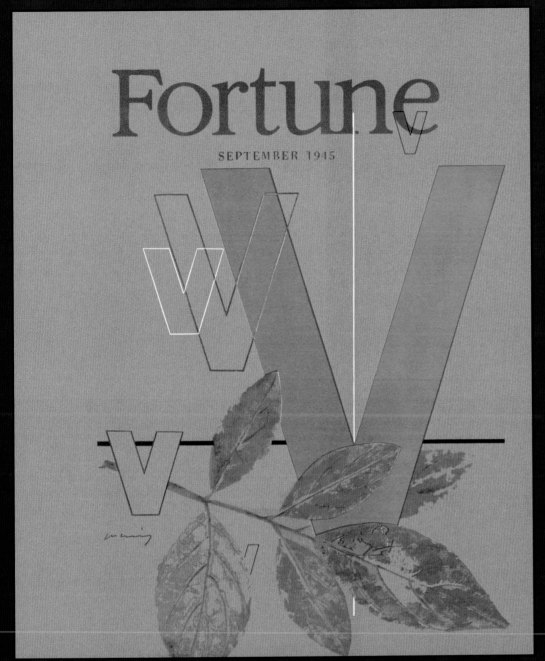

Fortune

SEPTEMBER 1945

Peter Piening

- *Franklin D. Roosevelt dies and Harry S. Truman becomes president*
- *U.S. drops atomic bomb on Hiroshima and Nagasaki*
- *George Orwell's novel* Animal Farm *is published*

U.S. GNP
Billions

$211.9

U.S. INCOME
Per Capita

$1223.00

UNEMPLOYMENT
Yearly Average

1.9%

FROM SEPTEMBER 1945: *The Job Before Us: The Triumph*

The war for human decency is won, and now the U.S. stands out as the inheritor of more power and more responsibility than any nation on earth. Other peoples suffered more; other armies spilled more blood. But by the prowess and heroism of its arms, by the sheer impact of its industrial might, by its courage in rising to great political challenges, the U.S. has assumed a unique position. Partly against its will—certainly without seeking the prize—it has become the guardian and standard-bearer of Western civilization. If the defeat of Japan is a time for profound thanksgiving, it is likewise a time for profound thought. We stand at a momentous turning.

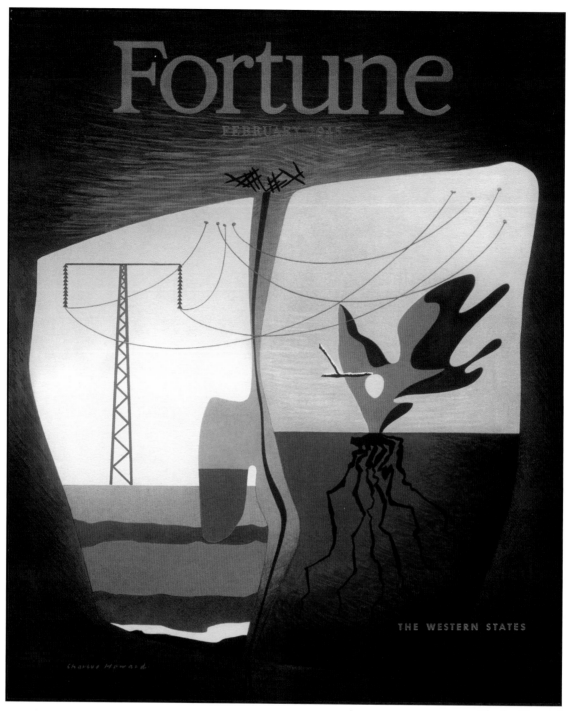

Charles Howard

FROM FEBRUARY 1945: *Ports of the Pacific*

The most exciting business on the West Coast is not a business at all. It is the Pacific Ocean, across which come the winds, the waves, and the ships from the canal, Alaska, Australia, and the Orient. To receive and load the ships that sail it there are longshoremen, exporters, underwriters, bartenders, bankers, seamen, municipal corporations, and the U.S. Government.... Serving the Pacific is exciting, for its ports have the strong personality that men mark and remember. And some of their personality is their westernness, for they face, not Europe about which Americans know, but the Orient about which Americans dream.

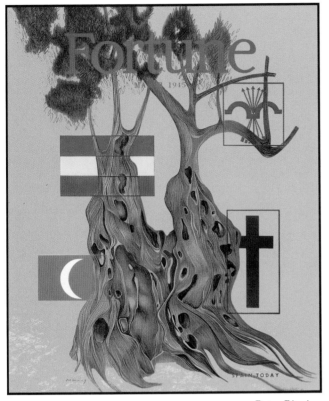

Peter Piening

Ralston Crawford

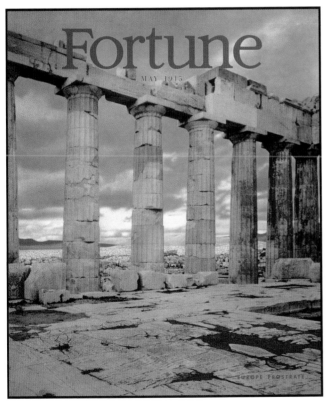

Dmitri Kessel

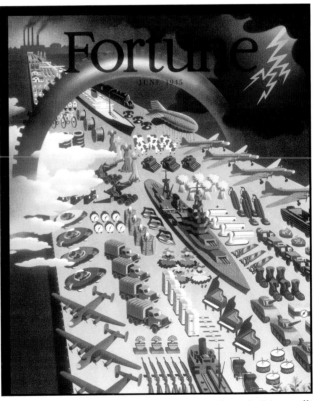

Antonio Petruccelli

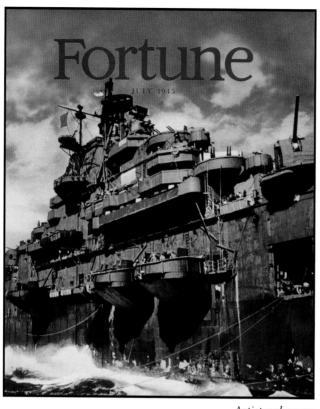

Artist unknown

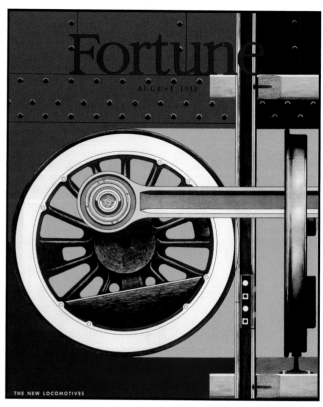

Alexander Semenoick

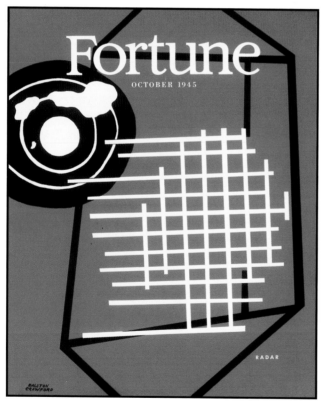

Ralston Crawford

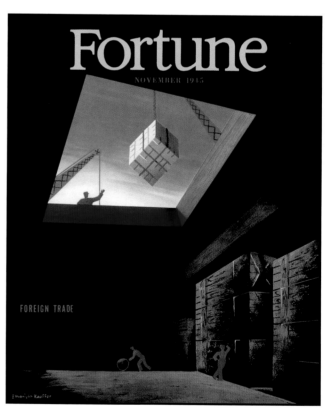

E. McKnight Kauffer

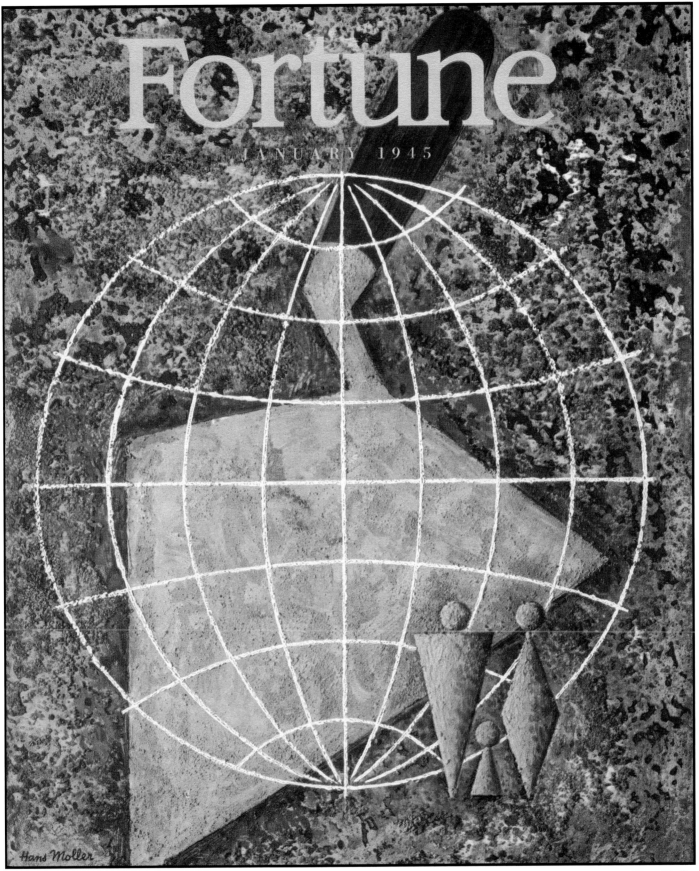

Hans Moller

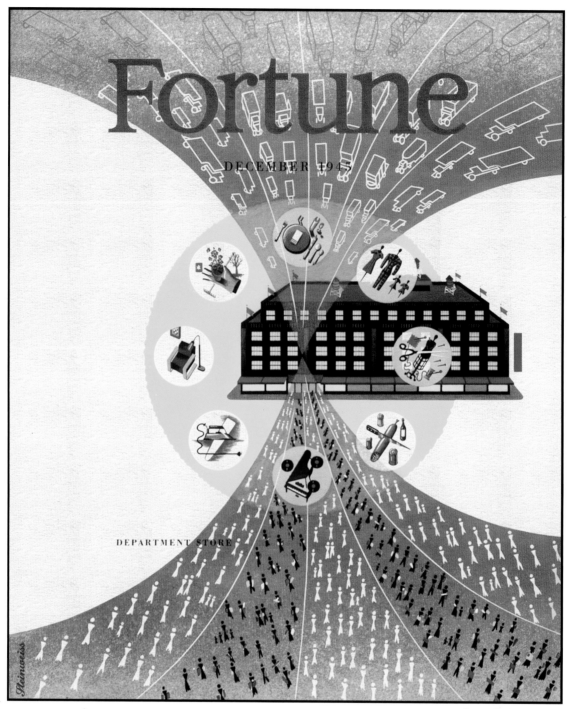

Alexander Steinweiss

FROM DECEMBER 1945: *Marshall Field, the Store*

A store's prestige does not live by merchandise alone. The personal touch of its service departments is as profitable to the store as it is costly to maintain. A few years ago Field's was asked by the executors of an estate to refund the price of a pair of real silk stockings purchased by the deceased twenty years before but never worn. The refund was paid promptly. This unquestioning acceptance of the idea that even the dead customer is always right pleased management as much as it would have gratified the founder.

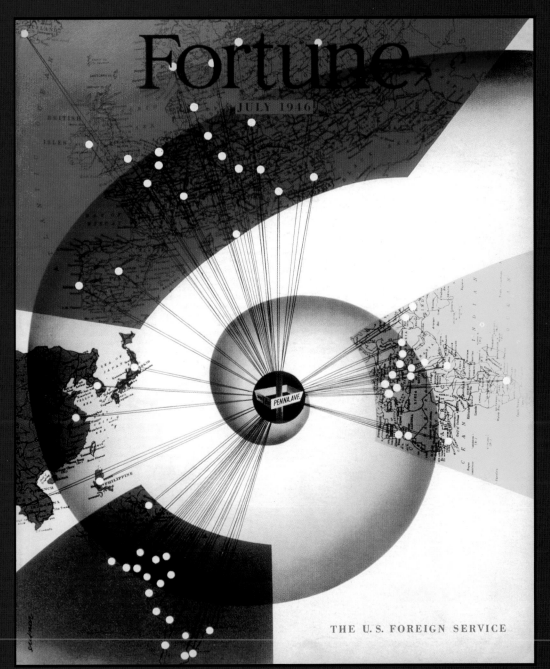

L. Sutnar

1946

• *Nuremberg Tribunal tries Nazi leaders for war crimes*
• *Dr. Benjamin Spock's* Common Sense Book of Baby and Child Care *is published*
• *Tupperware is introduced*

U.S. GNP
Billions

$208.5

U.S. INCOME
Per Capita

$1264.00

UNEMPLOYMENT
Yearly Average

3.9%

FROM JULY 1946: *The U.S. Foreign Service*

The young [career] officer is subjected to an appalling load of routine and humdrum duties, of which the greater part could be handled by a competent clerk. Curiosity, imagination, and initiative are deadened. The paper work keeps the officer so busy that he sees only a narrow segment of the life in the country where he is working. He moves in an inbred society and he loses touch with his own country. . . . If, like 90 percent of the corps, he was unmarried when he entered the service, he will remain a bachelor unless he finds a wife on one of his brief trips home or marries a foreigner (in which case he must submit his resignation and wait for the department, if it approves the girl, to decline the resignation). Married, he finds that his wife's talents as a hostess and her rating with the Ambassador's wife have a good deal to do with his own chances of promotion.

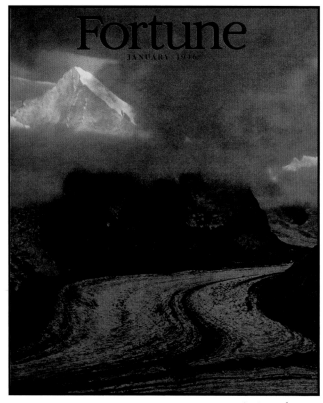

Artist unknown

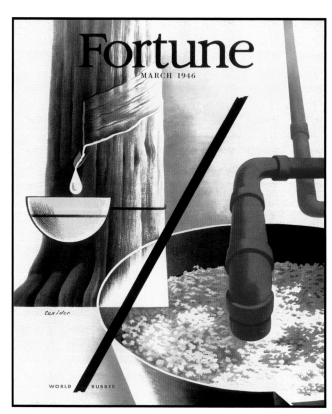

Fernando Texidor

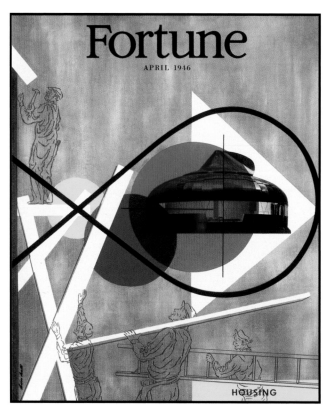

Artist unknown

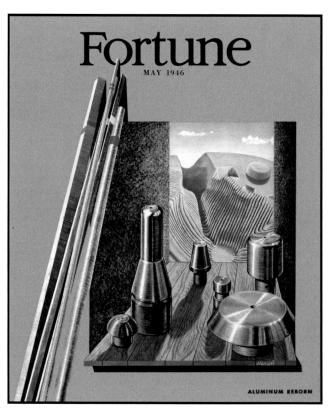

Harari

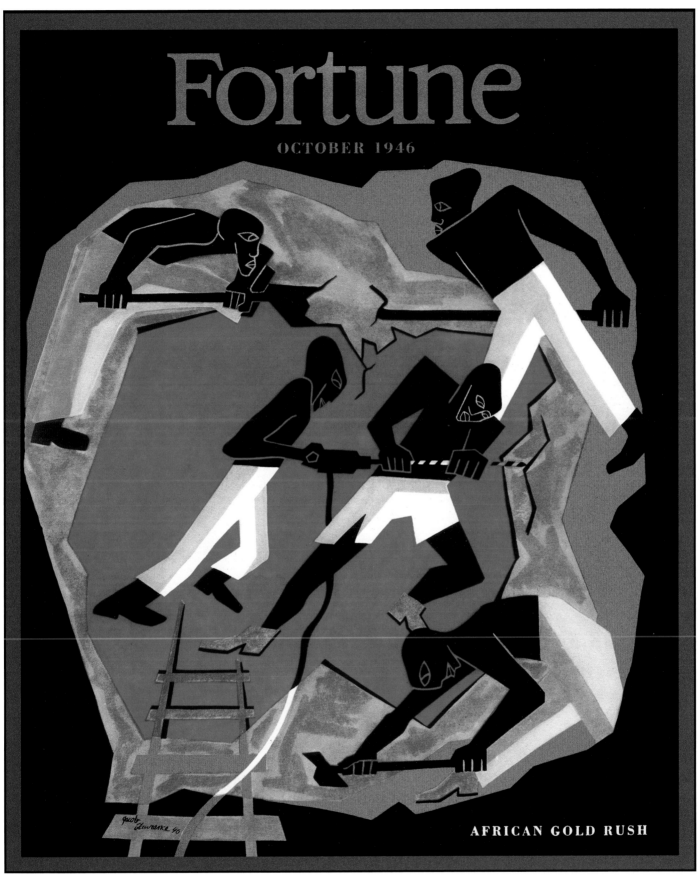

Fortune

AFRICAN GOLD RUSH

Jacob Lawrence

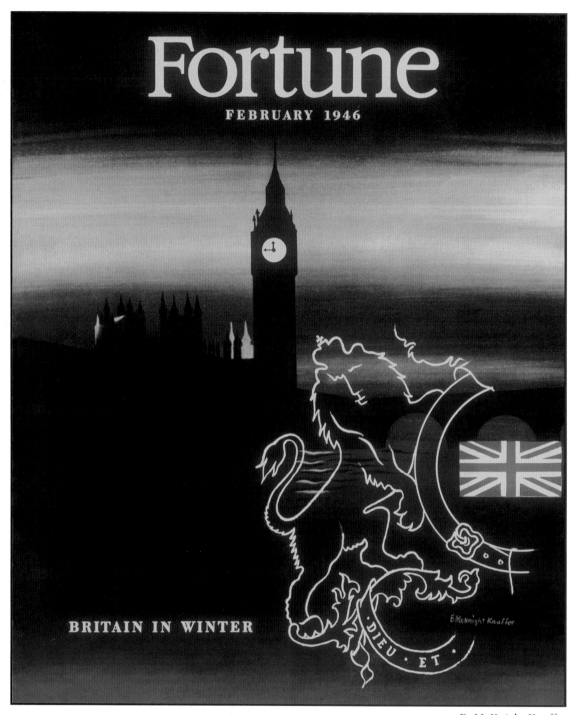

E. McKnight Kauffer

FROM FEBRUARY 1946: *Strength Through Misery*

Victorious and at peace, Great Britain functions almost as if she had won neither peace nor victory. Shop windows, still partly boarded up against a bomb blast, helplessly display their austere "utility" clothing, and concerts start at 6:30 P.M. and the streets are deserted long before midnight. And everywhere there are queues. Housewives queue for 25 cents worth of meat, the weekly ration. Office workers queue for newspapers that talk vaguely of better times. Everybody queues for busses, and sometimes its seems that if a barrel of sovereigns were overturned in the street, people would queue for them.

Arthur Lidov

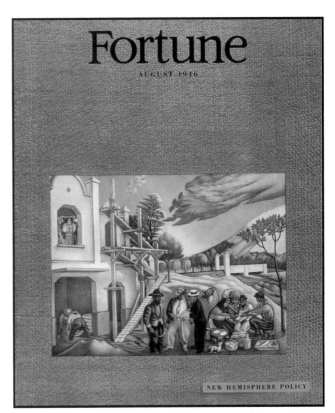

Antonio Ruiz

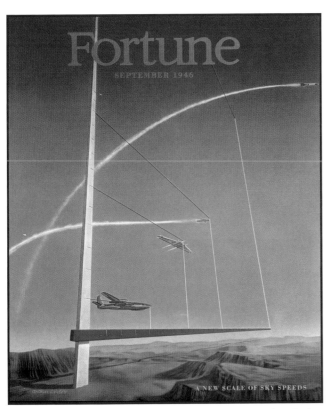

Arthur Lidov

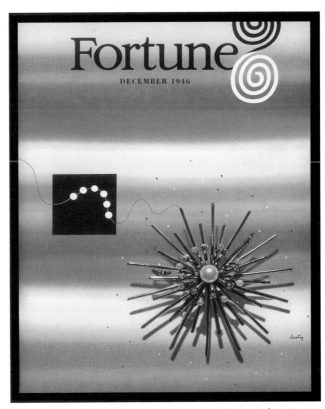

Alvin Lustig

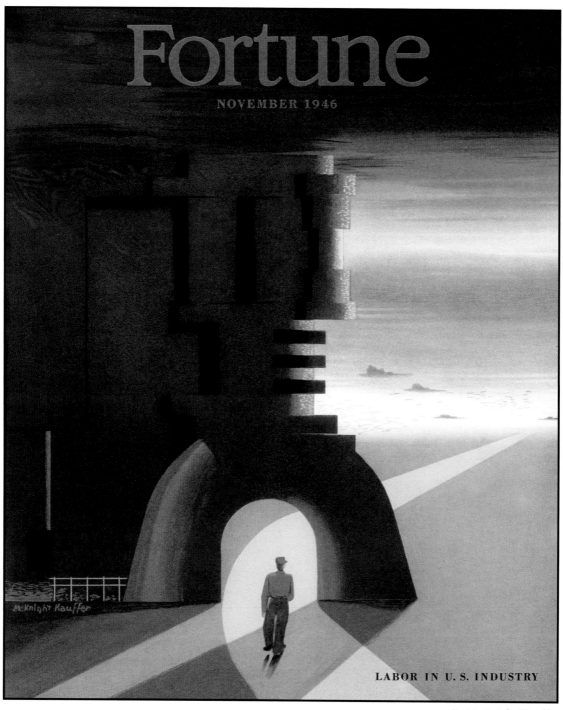

E. McKnight Kauffer

FROM NOVEMBER 1946: *Labor's Cause*

The worst intellectual sin of trade-unionism, besides its failure to define where it wishes to go, has been to confuse ends and means. But what is true for unions is likewise true for management. The credentials of competitive capitalism are not that it is some immutable God-given system, but simply that to date it is one viable means for getting the work of the world done without that overconcentration of economic power that spells the end of human liberties. It is when means are mistaken for ends that human society falters. It is only as the ends of man are reaffirmed that this nation will regain what Wendell Wilkie once defined as the "faith that is America."

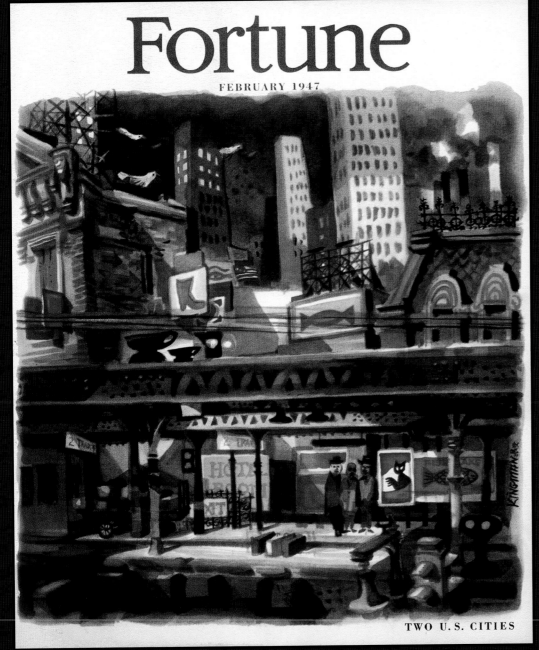

FEBRUARY 1947

TWO U.S. CITIES

Dong Kingman

• *Marshall Plan provides U.S. aid to war-devastated Europe*
• *Jackie Robinson becomes the first African-American to play on a major league team*
• *Anne Frank's* Diary of a Young Girl *is published*

U.S. GNP
Billions

$231.3

U.S. INCOME
Per Capita

$1327.00

UNEMPLOYMENT
Yearly Average

3.9%

FROM FEBRUARY 1947: *Chicago*

Progress. Chicago has shouted it, believed in it, imitated it, and verily sweated it for several generations. But it has simply not had the time to brew for that mirage a definition or an evaluation. Perhaps the word money has served. Anyway, money is soldered to all the things Chicago has given the world: the mail-order catalogue, the sleeping car, mechanized gang warfare, the steel-frame skyscraper, the department store—not to mention the greatest heave of cultural aspiration since the fall of Rome.

Fortune

AUGUST 1947

ITALY

Ben Shahn

Ezra Stoller

Lester Beall

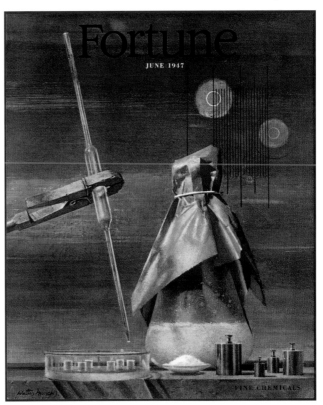

Barrett Gallagher

Walter Murch

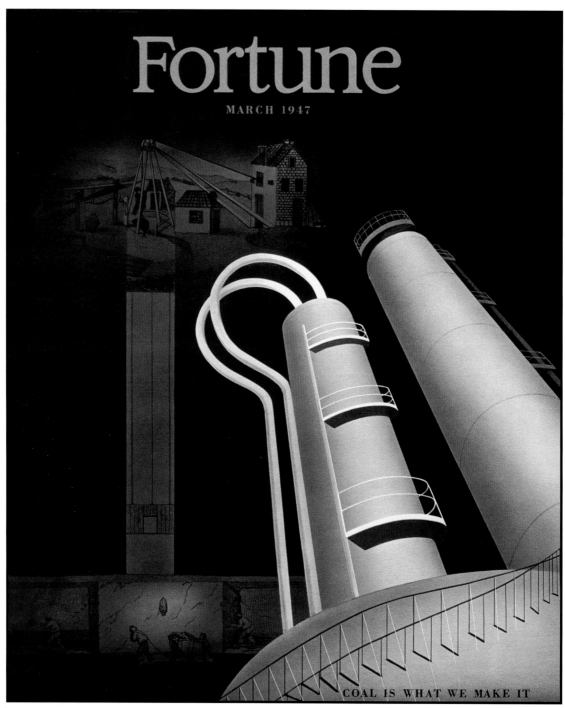

COAL IS WHAT WE MAKE IT

Matthew Leibowitz

FROM MARCH 1947: *Coal: The Industrial Darkness*

Imagine an industry more basic than steel; upon which even steel depends; upon which the great and magnificently ingenious chemical industry in large part relies—in turn the producer of fertilizers for the entire agricultural cycle; of drugs and dyes; of fabrics, paints, and plastics. Imagine an industry to which the railroads are so deeply beholden that they could not run without it. And then imagine that that same industry cannot, over the long range, make any money at all. That is the coal industry.

Victor Jorgensen

Arthur Lidov

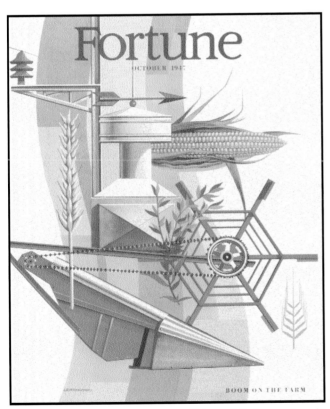

Edmund D. Lewandowski

Matthew Leibowitz

Hans Moller

FROM NOVEMBER 1947: *Making the Free Market Free*

The fact is that Europe is not going to recover without some further first aid and stop-gap treatment. Five years—the span of the Marshall proposals plus a year—is not a long time. But five years can work wonderful transformations. Five years ago this country and its allies were at the nadir of their fortunes in a military sense. . . . In the war, victory came dramatically and cumulatively. Who will say that five years from now we may not see a like transformation in the economic scene—a transformation that will allow the great American salesman to step out on a wider stage than his own forty-eight states.

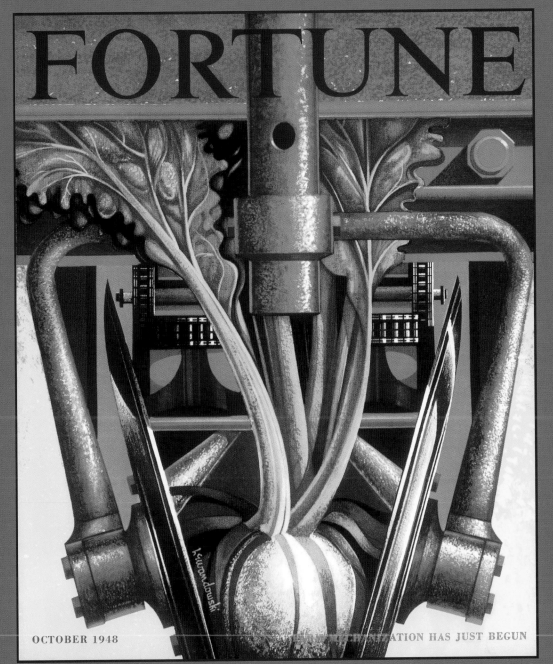

OCTOBER 1948

FORM MECHANIZATION HAS JUST BEGUN

Edmund D. Lewandowski

1948

- *U.S. recognizes Israel*
- *Selective Service Act authorizes the registration and drafting of men between 18 and 25 years old*
- *Polaroid introduces the first instant camera*

U.S. GNP
Billions

$257.6

U.S. INCOME
Per Capita

$1434.00

UNEMPLOYMENT
Yearly Average

3.8%

FROM OCTOBER 1948: *The Machine and the Farm*

Both the avidity of the farmer for mechanization and his present cash position are, of course, products of the war, but they are wholly new phenomena in the history of agriculture. It would be difficult to overestimate what they imply for the future of farming. But there is general agreement—perhaps the one agreement that can be found in the highly controversial field of agriculture—that the U.S. farm promises the greatest opportunity for advance of any major area of the U.S. economy. In short, the most astonishing fact about farming today is that the agricultural revolution is not complete; it is just beginning its final phase.

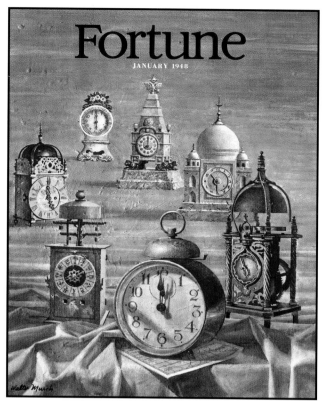

Walter Murch

Hans Moller

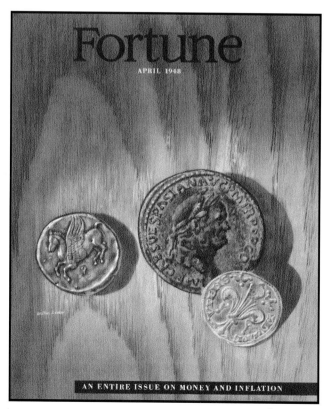

Arthur Lidov

Herbert Matter

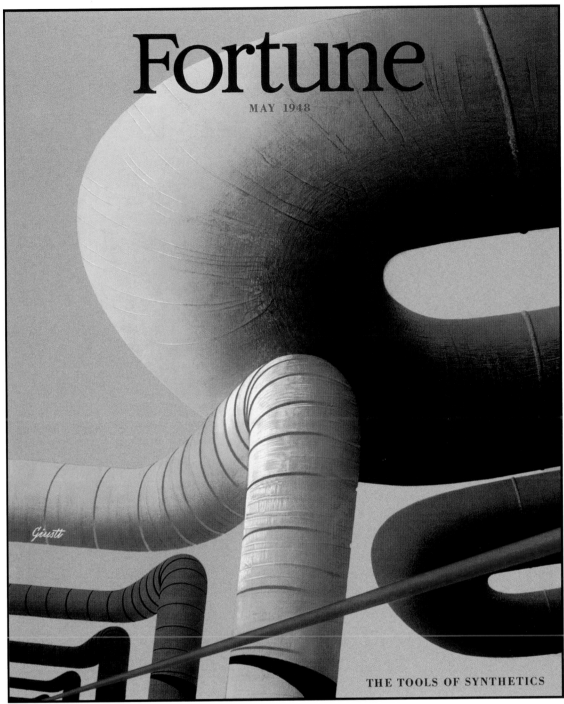

Fortune

MAY 1948

THE TOOLS OF SYNTHETICS

George Giusti

FROM MAY 1948: *Television! Boom!*

Nothing about the ultimate place of television in the family, the economy, or the body politic can be proved from the soaring statistics of the industry or from the feverish activities and opinions of the people now trying to latch onto the television bandwagon. In fact, there are as many conflicting answers to all the $64-million questions tossed up by big-time video as there are conflicting interests in the field. . . .

When pressed for certainties, nobody knows what is going to happen. The only area of general agreement is that whatever happens, it will be terrific.

127

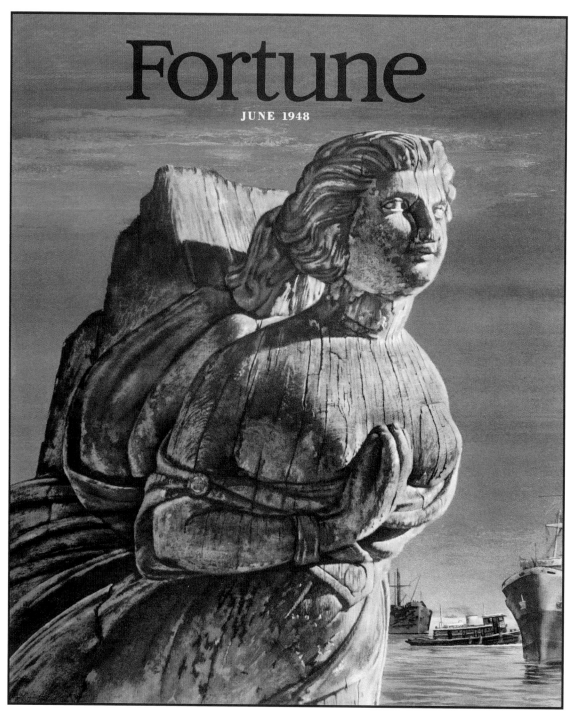

Arthur Lidov

FROM JUNE 1948: *Fortune Survey: Palestine Question*

What do you think of the United Nations' proposed plan to divide Palestine into two separate states, one for the Jews and one for the Arabs?

	Total
Approve partition	26%
Should try some other plan	31
Haven't thought much about it	31
Express no opinion	12

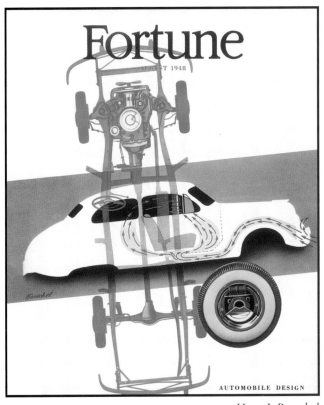

Hans J. Barschel

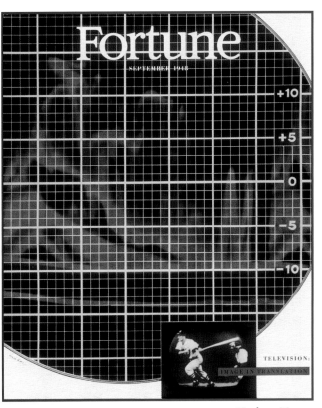

Herbert Matter

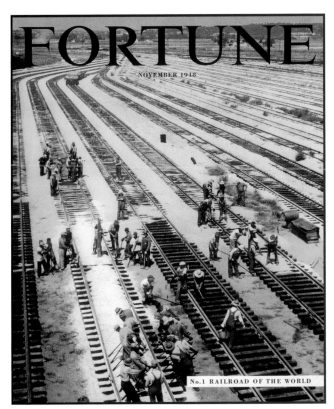

Artist unknown

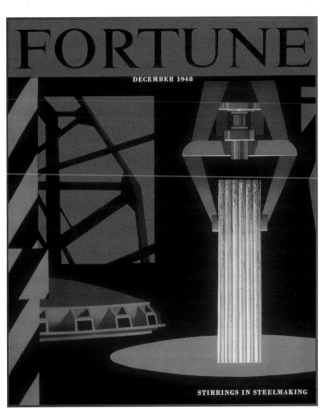

Edmund D. Lewandowski

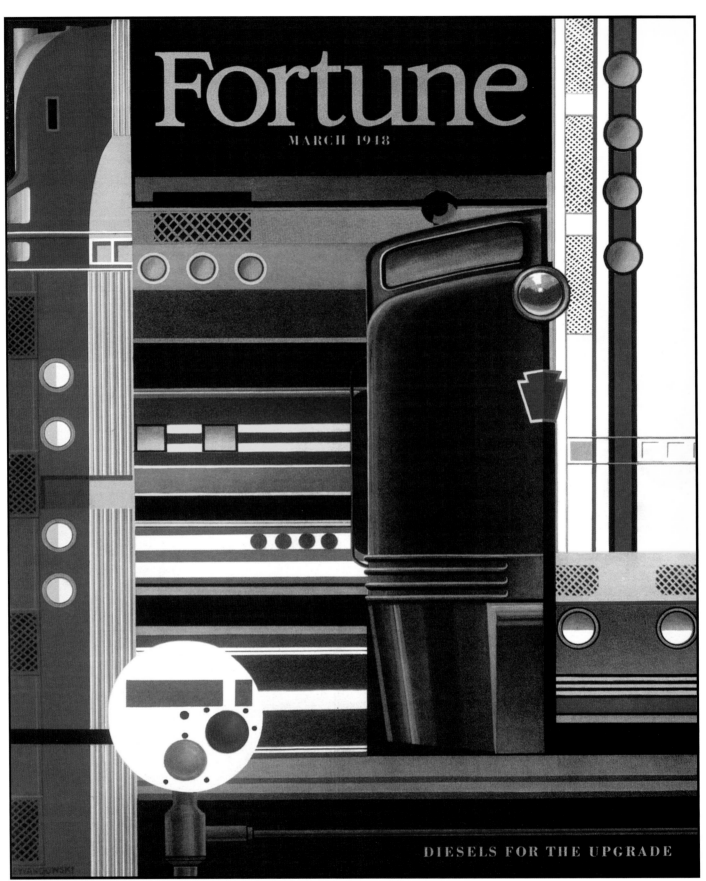

DIESELS FOR THE UPGRADE

Edmund D. Lewandowski

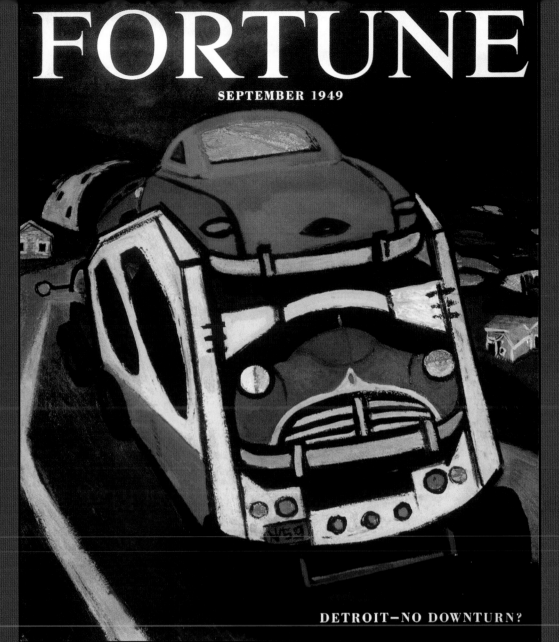

FORTUNE
SEPTEMBER 1949

1949

• North Atlantic Treaty Organization is established
• American Cancer Society warns that cigarette smoking may cause cancer
• Bikini bathing suits are introduced in America

U.S. GNP
Billions

$256.5

U.S. INCOME
Per Capita

$1389.00

UNEMPLOYMENT
Yearly Average

5.9%

DETROIT—NO DOWNTURN?

Gregorio Prestopino

FROM SEPTEMBER 1949: *Motors: They're Still in High*

Though the automobile has remade the social complexion of this country, and the industry is commonly referred to as "the dominant industry in the U.S. economy" in the sense that it is one of the largest employers, the biggest consumer of steel, glass, rubber, etc., it has never, in fact, been the boss of the economy. On the contrary, it has been the economy's darling, carefree child, riding the crest of the prosperous periods, plumbing the depths of depressions, and never appearing to exert much control over its own destiny.

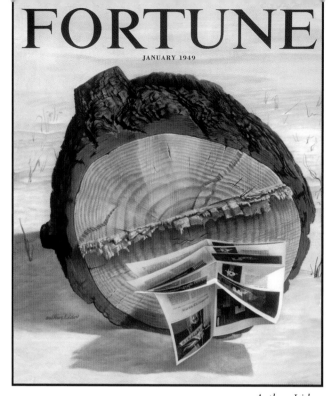

Arthur Lidov

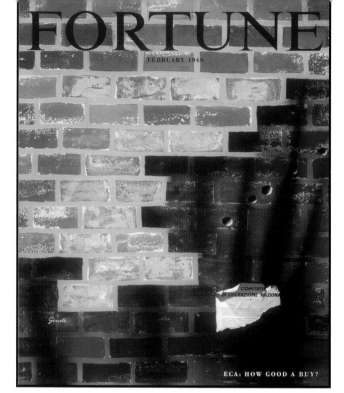

George Giusti

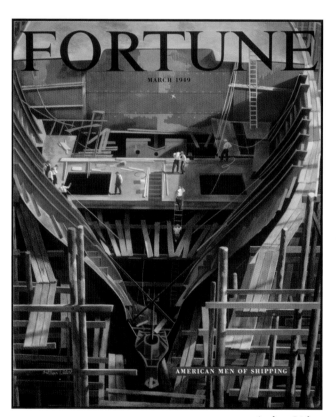

Arthur Lidov

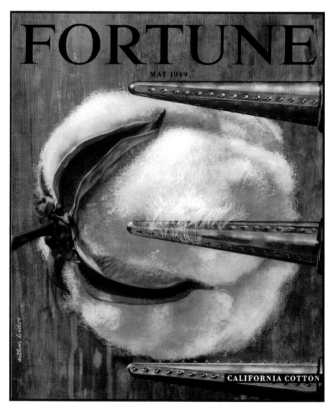

Arthur Lidov

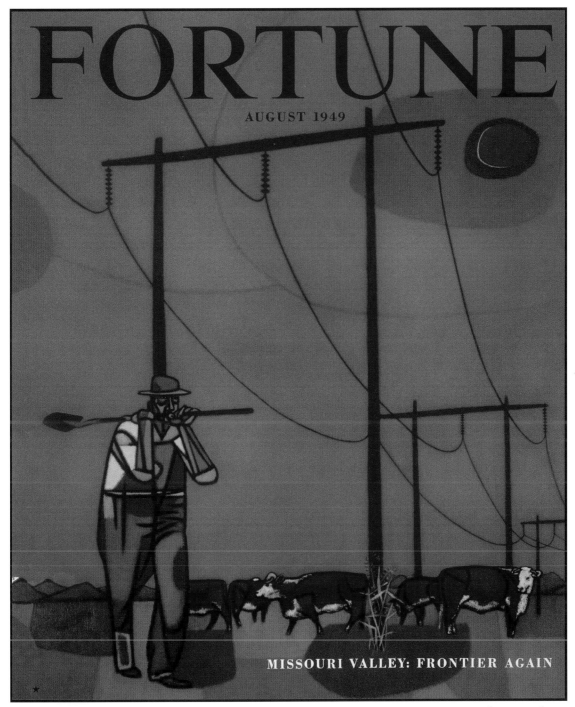

FORTUNE

AUGUST 1949

MISSOURI VALLEY: FRONTIER AGAIN

Robert Gwathmey

FROM AUGUST 1949: *The Missouri Valley*

That estimable Missouri "river rat," George Fitch, once wrote: "There is only one river that goes traveling sidewise, that interferes in politics, rearranges geography and dabbles in real estate." Fitch hardly exaggerated. The Missouri has switched towns from bank to bank and state to state, in total disregard, for example, of the Kansas dry laws; it has forced men to build bridges on dry land and then balked at entering neatly laid-out channels beneath; it can count among its relics steamboats now buried in alfalfa and docks that have come to know nothing more moist than a cat's tongue.

133

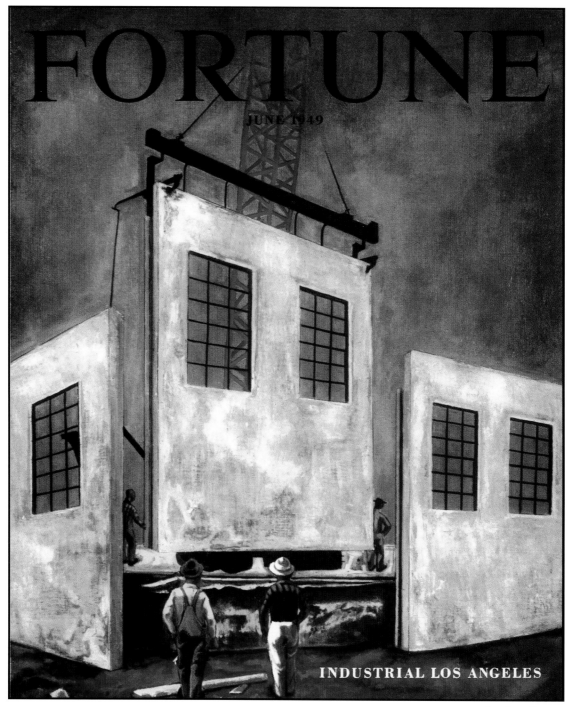

FORTUNE

JUNE 1949

INDUSTRIAL LOS ANGELES

Stephen Greene

FROM JUNE 1949: *The Undiscovered City*

For all its functional factories and six-lane traffic jams, Los Angeles has something of the air of the nineteenth century. More persuasively, perhaps, than any other place outside the Southwest, it appeals to the old-fashioned American belief that a growing town is a wonderful place for risking and making money. The atmosphere would not be authentic without an occasional reminder that growing American towns have always inspired a certain number of bad business guesses.

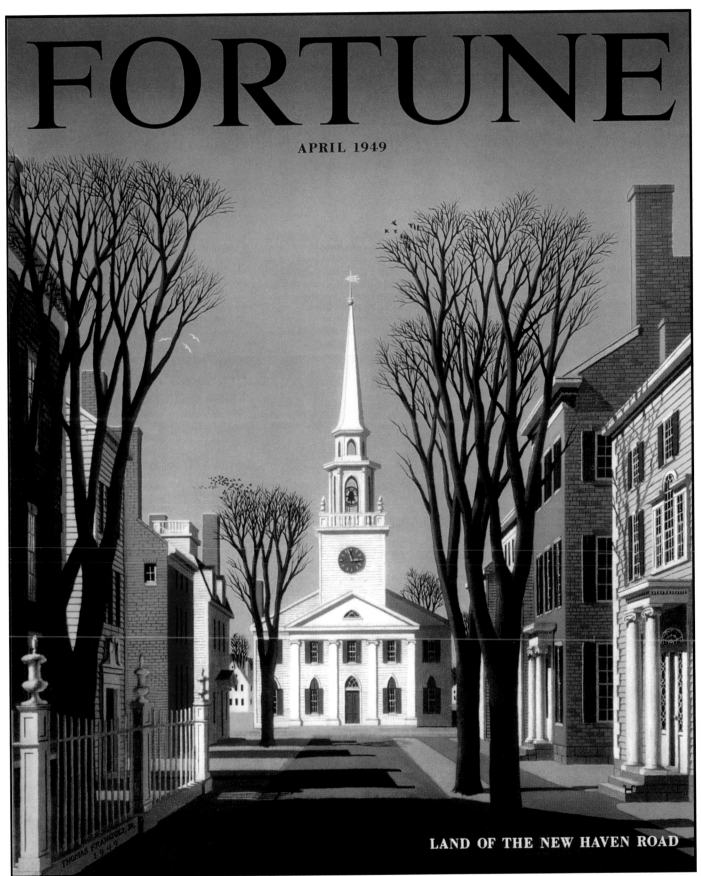

FORTUNE

APRIL 1949

LAND OF THE NEW HAVEN ROAD

Thomas Fransioli

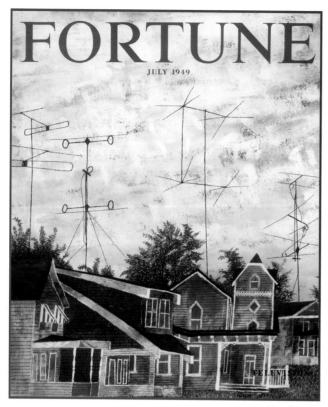

Ben Shahn

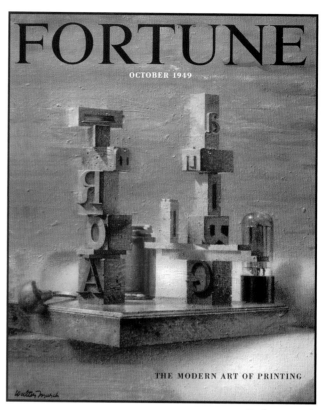

Walter Murch

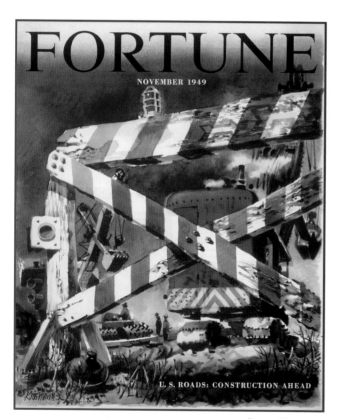

Dong Kingman

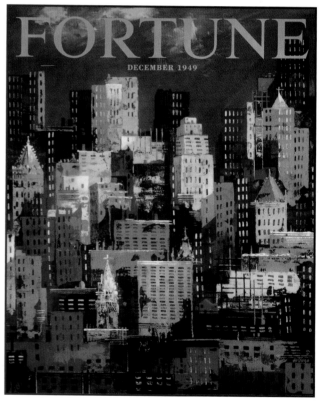

Julio de Diego

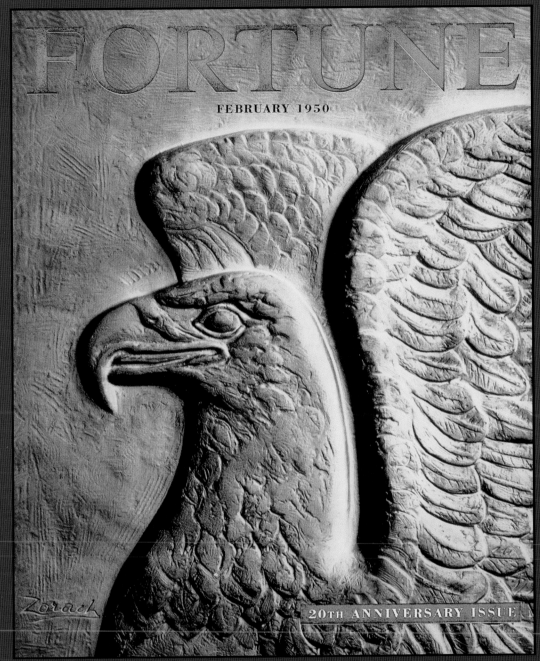

1950

- *Truman approves development of hydrogen bomb*
- *Abstract impressionist Jackson Pollack popularizes "drip" painting*
- *Charles Schultz creates Peanuts comic strip*

U.S. GNP
Billions

$284.8

U.S. INCOME
Per Capita

$1501.00

UNEMPLOYMENT
Yearly Average

5.3%

William Zorach

FROM FEBRUARY 1950: *The Reformation of the World's Economies*

As Americans seek to lead the non-Communist world around the hazardous mid-point of the twentieth century, their chief instrument of constructive activity is—Business.

American Business is a powerful fact often hidden behind the more fashionable phrase, "the American economy." The American economy is certainly a "mixed economy," yet its chief engine, after no matter how much New Deal or Fair Deal, is still Business. The American workman works for a profit-and-loss business; the farmer who sends food to market is very much a businessman; and the millions of civil servants, schoolteachers, clergymen, painters, poets, and other non-profit-seeking members of our society are for the most part fed and housed from the taxes on, or proceeds of, profit-seeking Business.

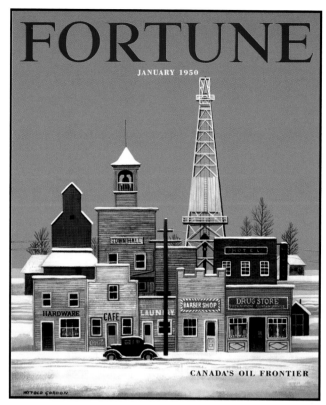

Witold Gordon

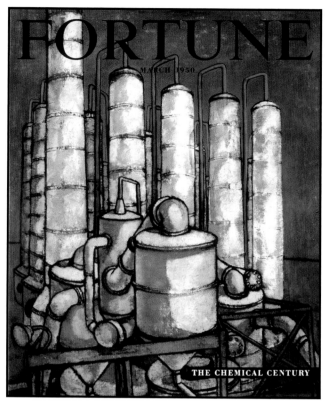

Arthur Osver

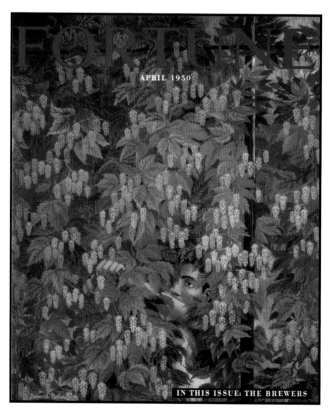

Bernard Perlin

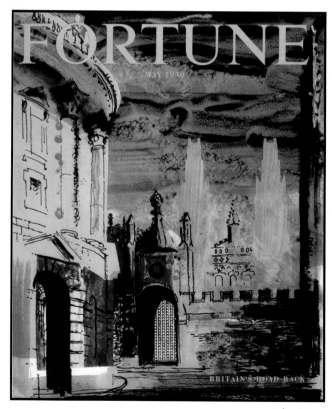

John Piper

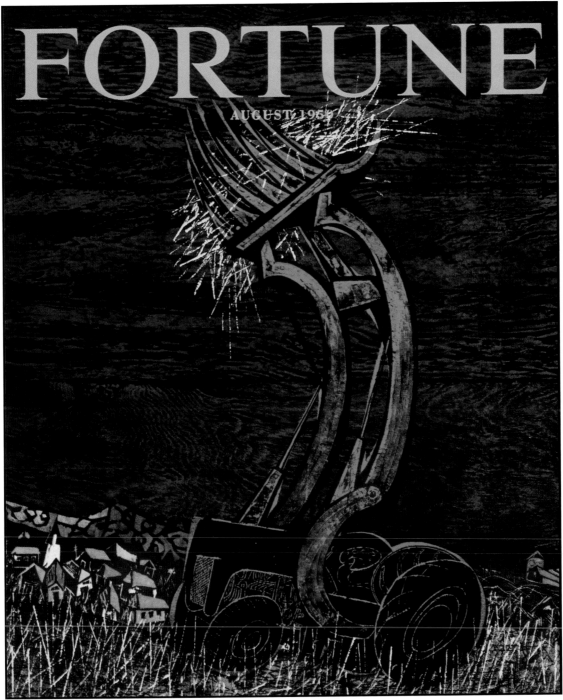

Antonio Frasconi

FROM AUGUST 1950: *The Graduate Business School*

The typical graduate student comes directly from college. If he has any work experience at all it is as a counselor in a summer camp; or maybe he has sold subscriptions to the *Saturday Evening Post*. He has never lived as an adult in an adult world, has never been on his own, and, above all, he lacks business experience. . . .

The most common complaint against the business schools in the business community is that they encourage their graduates to look upon themselves as "crown princes," if they do not actually implant the idea in their minds.

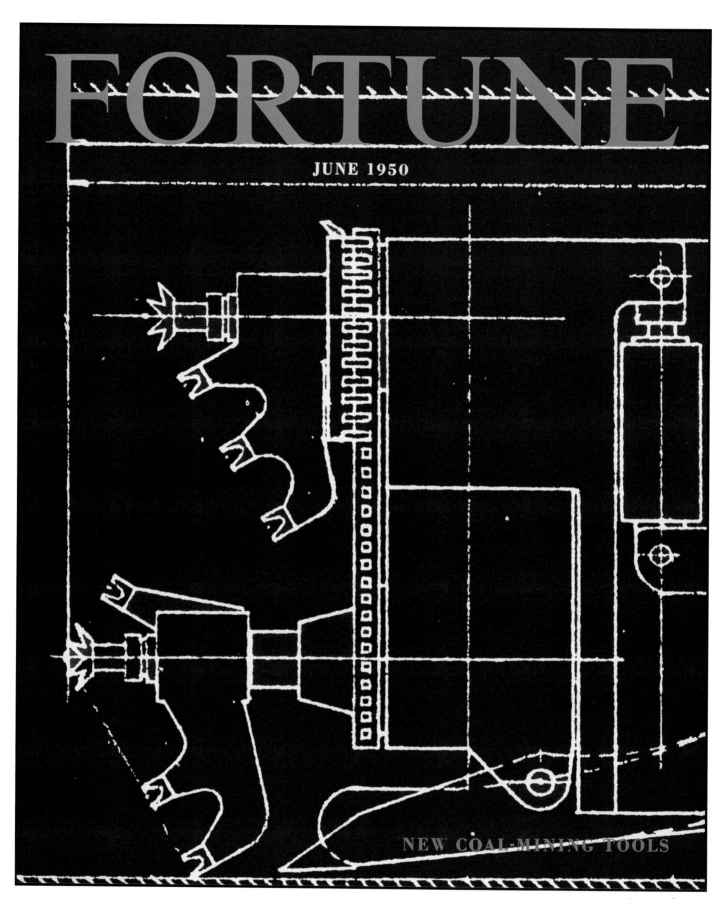

FORTUNE

JUNE 1950

NEW COAL-MINING TOOLS

Artist unknown

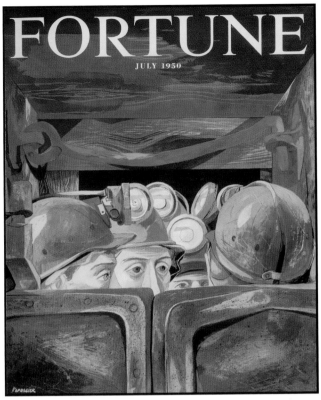

Anton Refregier

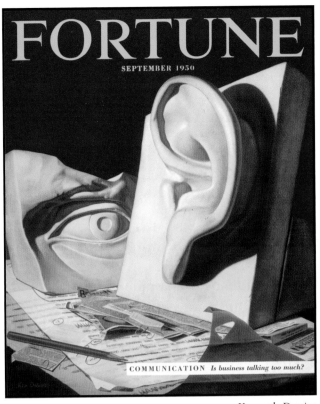

Kenneth Davies

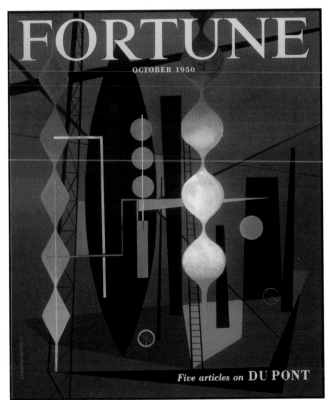

Erberto Carboni

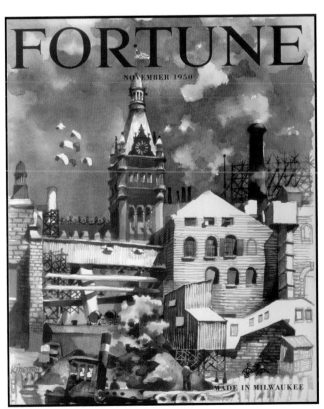

Dong Kingman

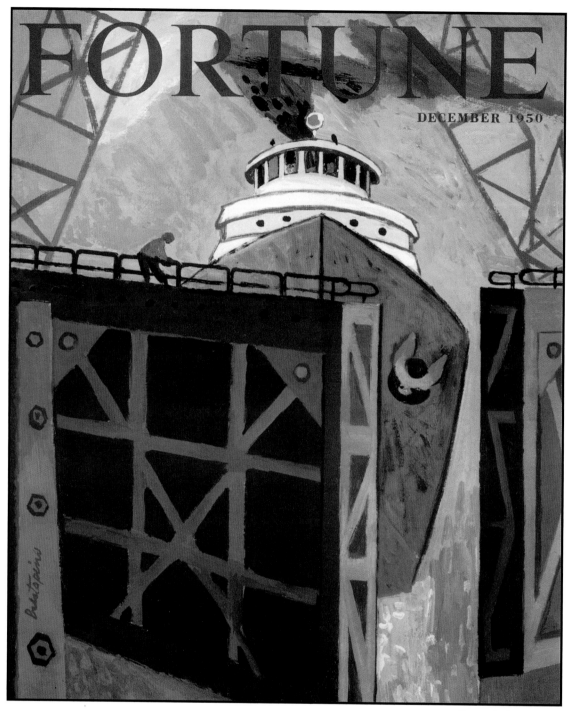

Gregorio Prestopino

FROM DECEMBER 1950: *Trillionism*

It is no news that a million dollars is now a shrunken sum, generally prefixed by such diminutives as "paltry," "measly," and "modest," or followed by a reference to "peanuts." The million was, of course, displaced by the billion as the basic unit of economic computation. What is unnerving news is that the billion itself seems to be on the way out. The U.S. is apparently entering the decade of the "trillion."